EASTSIDE
INDIANAPOLIS

EASTSIDE INDIANAPOLIS

A BRIEF HISTORY

JULIE YOUNG

THE
History
PRESS

Published by The History Press
Charleston, SC 29403
www.historypress.net

Copyright © 2009 by Julie Young
All rights reserved

First published 2009
Second printing 2013

Manufactured in the United States

ISBN 978.1.59629.683.1

Library of Congress Cataloging-in-Publication Data

Young, Julie.
Eastside Indianapolis : a brief history / Julie Young.
p. cm.
Includes bibliographical references.
ISBN 978-1-59629-683-1
1. Eastside (Indianapolis, Ind.)--History. 2. Neighborhood--Indiana--Indianapolis--
History. 3. Community life--Indiana--Indianapolis--History. 4. Indianapolis (Ind.)--
History. 5. Indianapolis (Ind.)--Social life and customs. I. Title.
F534.I36E249 2009
977.2'52--dc22
2009019605

To my mother...for everything.

CONTENTS

ACKNOWLEDGEMENTS

As an author, I have learned that no book project is ever a solo act. This work could not have been completed without the help of a number of individuals and organizations who embraced this vision and were ready to come along for the ride.

First and foremost, I have to thank Diane Roudebush, who dropped off her Tech High School material and encouraged me to scan it, "just in case you ever do another book about the East Side." Without her, this book never would have materialized.

I also have to acknowledge the various contributions of the Woodruff Place Civic League, Little Flower Catholic Church, Scecina Memorial High School, the Irvington Historical Society, the Eastgate Neighborhood Association and the YMCA of Greater Indianapolis.

To every individual who contacted me and offered their personal collections for the project, I thank you all, including Greg Bierck, the Shortridge family, Kathleen Angelone, Dorothy Everett, the Eichackers, Ron Huggler, Steve Barnett and Jack Hensley. Your input and contributions made all the difference.

A big thanks to Jonathan Simcosky and everyone on staff at The History Press. This has been an enjoyable and (nearly) stress-free process. I had a great time working with you, and I can't wait to do it again soon.

To my web designer and good friend Ron Kidwell: you are in every way one in a million, and you have my gratitude for your creativity, talent and ability to always make me laugh.

To all of my friends who made my Eastside childhood so memorable: Jack, Robi, Vicki, Pam, Christy, the Little Flower class of 1986 and Scecina's class of 1990. You are the best, and there is a special place in my heart for all of you.

To my brother, Bruce Johnson, who didn't get to go to Elvis's last concert but was nice enough not to hate me when I did. I love you so much! To my

dad, Jeff Johnson: you continue to share your special gifts with me, and I miss you more than you will ever know.

And finally, to my sons, Chris and Vincent: Remember that impossible is nothing, and if you listen very hard, the tune will come to you at last. Dream on, dream big and dream until your dreams come true.

INTRODUCTION

T hroughout the writing of this book, I have told many family and friends, "The next time I decide to take on 25 percent of a major city, remind me to have my head examined." While everyone laughs good-naturedly about the amount of time and effort I have put into this project, the real discovery I made while writing this book is that the Eastside means a great deal to a vast body of people, and trying to encapsulate it is next to impossible. While everyone's memories may be different, Eastsiders are a fiercely loyal bunch. No matter where you go in life, the connection to the Eastside remains. As Irvington historian Steve Barnett told me, "It's a state of mind."

For me, this book is very personal. My own Eastside roots run deep, and most people have heard me say that I couldn't be more Eastside if I tried. I grew up about three blocks from Community Hospital, attended Little Flower Catholic School and Scecina Memorial High School and had family members who lived in Irvington and others who worked along the Shadeland Corridor. My father was the worshipful master at the Brookside Masonic Lodge, and my grandfather was part owner of a business near Our Lady of Lourdes. I was a Washington Square "mall rat" in the 1980s, and today I reside near Warren Central High School. Without a doubt, I am an Eastside girl!

Over the years, I have heard countless stories and have seen many changes on this side of town. Anyone will tell you that the Eastside was a great place to grow up, whether you saw Saturday matinees at the Rivoli Theatre or viewed *Star Wars* on the Eastwood's curved screen and heard the buzz of light sabers for the first time on a (then) state-of-the-art sound system. Hangouts might have included the Double L or the Steer-In, while a special occasion might have called for a visit to Mickler's on U.S. 40 or the Paramount Music Palace with its mammoth pipe organ, whose console "magically" rose from its pit and electrified the room with its sights and sounds.

The Eastside is home to any number of colorful characters, both malignant and benign. Names such as Stephenson, Holmes and Baniszewski are synonymous with the neighborhoods they made infamous, while others, like the eccentric owner of Al Green's Famous Food, became legends in their own time.

"He's in there," my dad used to tell me ominously as we passed the Greens' pink stucco building on Washington Street. It was as if Boo Radley from *To Kill a Mockingbird* might be hiding inside. "You know the state pays him to live there."

Whether that story was true or not, there are plenty of tales to tell. The location of major industrial plants such as International Harvester, Ford, Chrysler, Western Electric and Naval Avionics on the Eastside made it a thriving community, and the changes that have occurred with these employers have made for difficult losses. In recent years, there have been many revitalization attempts in various neighborhoods throughout the Eastside, which gives me hope that this side of Indianapolis still has much to offer the city.

I realized early on in this project that it would be tough to capture everything I wanted to feature in a small volume. After all, where was I to begin? I had to determine the boundaries of the Eastside, and I quickly discovered that this was largely determined by the individual. Was Woodruff Place too close to downtown? Was Fountain Square too far south to be considered? The answers varied depending on whom I talked to and where they came from. In fact, one person I interviewed mentioned that she lived "in Indianapolis" in the 1940s, though based on current boundaries, she still does. It illustrated to me that, as old as this side of town is, it has changed many, many times.

For this volume, I wanted to create a celebration of the Eastside that would highlight not only the neighborhoods but also the people and the places we remember fondly that are also pages of our past. I tried to balance text with pictures in order to include as much as possible. Time and space made creating a tome impractical, but rest assured, there is plenty to be explored. I hope that *Eastside Indianapolis: A Brief History* sparks some memories and offers readers new knowledge about the place we call home. Enjoy!

A GROWING CITY

Robert Frost once said, "Good fences make good neighbors." Many of the early Eastside communities strove to establish themselves beyond the growing city of Indianapolis, which had become a bustling railroad and commercial center following the Civil War. The original plan for Indianapolis when it was platted in 1821 called for a city of only one square mile, with a circular commons representing the center of the metropolis, similar to Washington, D.C. It wasn't long before the city began its outward expansion, fostering the development of pastoral suburbs in the surrounding open spaces.

Martindale-Brightwood

After the Civil War, Indianapolis's economy boomed, and the city quickly became known as a railroad town, with several lines coming into the city from various directions. Early neighborhoods cropped up along those railroad lines, including the Martindale-Brightwood area, which was platted in 1872 and designed by manufacturers Clement A. Greenleaf (famous for inventing the turntable to spin railroad cars and engines) and John L. Mothershead, along with merchants William D. and Daniel H. Wiles.

The initial railroad community of Martindale was settled in 1873 by Fredrick Ruschaupt, who, along with Gustav Zschech, operated the Indianapolis Car Works railroad machine yard. Within a year, the plat of Brightwood would be amended in order to incorporate new plans for a residential community that would surround the existing industrial and commercial areas. Employees of the "Bee Line" (the Cleveland, Columbus, Cincinnati and Indianapolis Railroad) were very supportive of the changes in the plat, and immediately, Brightwood became the city's railroad suburb.

Brightwood was a diverse community of skilled and unskilled immigrant workers of German, Irish and British heritage.

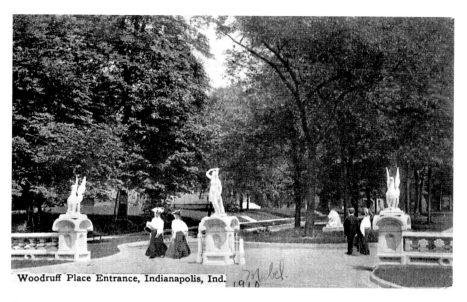

Woodruff Place Entrance, Indianapolis, Ind.

A postcard depicting an entrance at Woodruff Place. The esplanades and statuary were key to the neighborhood's park-like setting. *Courtesy of Bruce Burton.*

In 1875, Brightwood continued to grow as a major part of Center Township. A high school in the neighborhood, originally known as School No. 12, located at Twenty-seventh Street and Sherman Drive, was established. The school was eventually razed after Brightwood was annexed into the city of Indianapolis, but in the meantime, the suburb was its own town, enjoying its stature as a residential and industrial community.

In the latter part of the nineteenth century, the citizens of Brightwood secured a railroad repair yard and shops that were opened by the Bee Line. The Brightwood Methodist Church and the Hillside Christian Church (Disciples of Christ) were established. Municipal infrastructure also began to make its way into the suburb as well, through a private waterworks and the organization of volunteer fire departments—the Wide-A-Wakes, at Twenty-fifth and Station Streets, and the Alerts, at Roosevelt Avenue and Olney Street.

In 1897, Brightwood was annexed into the city of Indianapolis, having earned a reputation as a thriving community of four thousand people living in cottage homes in an area that some considered to resemble a large park. More schools, churches and other amenities, such as Douglas Park, followed annexation. Into the early twentieth century, electric car service, utilizing the railroad running alongside the suburb, connected the community with downtown, making Brightwood a desirable working-class

neighborhood in which to raise a family. About four-fifths of the workers in Brightwood were dependent on the railroad for their livelihood, and as with all working-class areas, there were those who, from time to time, required help meeting their needs. They could find a variety of social services available to them, including free dental care and Red Cross food baskets for those who were malnourished.

Martindale also continued to grow and prosper as an industrial and residential area. Businesses that operated in the Martindale area included the Indianapolis Gas Works, Eggles Field Lumberyard, the National Motor Vehicle Company and the Monon Railroad yards.

The 1930s and '40s saw the apex of the Brightwood vision, with plenty of jobs, homes and amenities to meet the needs of its residents, but by the 1960s, most of the railroads had left the neighborhood and many of the middle-class population had migrated to the newer suburbs. Brightwood became a neighborhood in transition. An in migration of lower-income African Americans began to quickly fill the homes being vacated by middle-class residents. Though Station Street remained the business center of Brightwood, many of the individuals in the neighborhood were considered to be "poor" according to the guidelines set by the federal government. By the end of the decade, Brightwood was considered by the federal Model Cities program to be the area of Indianapolis most in need.

Although the area continued to decline and became a blighted neighborhood, the establishment of Martin University at 2171 Avondale Place in 1987 was a coup for Brightwood and marked the beginning of other programs locating in the neighborhood. The Baptist Theological Seminary and the Jireh Sports Facility offered residents a chance to envision a brighter future for the community, which had transformed from its early days as an Indianapolis industrial suburb.

Woodruff Place

Brightwood wasn't the only community to dream of a suburban utopia for itself apart from the confines of Indianapolis. In 1869, James O. Woodruff, a professional engineer, arrived in Indianapolis to develop the Indianapolis Waterworks. As a Victorian-era man of means, Woodruff longed to move out of the city boundaries and became enamored with the idea of creating a small subdivision that would be unique for its time.

Other nineteenth-century subdivisions were merely tracts of bare land cut into standard lots, but Woodruff wanted to create a well-defined community

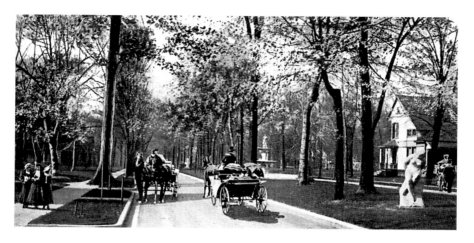

A 1906 postcard of Woodruff Place showing the Victorian homes, carriages, esplanades and statuary within the neighborhood. *Courtesy of Bruce Burton.*

with large, tree-filled lots and wide streets bisected by esplanades adorned with urns, statuary and fountains. He found the perfect spot for his vision just a mile out of town and adjacent to the National Arsenal. Woodruff purchased the seventy-six-acre tract known as the Dark Woods in 1872 and renamed the land Woodruff Place. Not only did the tract possess some of the most beautiful landscaping east of Indianapolis, but also, in time, it would become home to some of the wealthiest residents of the day.

"Mr. Woodruff was truly a visionary," said Sally Cook, Woodruff Place resident and member of the Woodruff Place Civic League. "It would be one hundred years before subdivision developers reinvented the concept of a gated community in a park-like setting."

Woodruff planned for the land to be inhabited by the rich and cultured citizens of the Gilded Age. The initial plat consisted of 180 lots on four streets: West Drive, Middle Drive, East Drive and the bisecting street, Cross Drive. The lots themselves were priced at $8,000, with the provision that the new owners would invest at least $20,000 into their new homes.

At every intersection, there was a multi-tiered fountain; the east fountain was rumored to be based on the fountain displayed at the 1876 Philadelphia Exposition during the country's centennial celebration. The fountains were only part of the statuary and urns located in the new community, but the *pièce de résistance* of the neighborhood was the houses themselves, modeled in the Neo-Jacobean and Eastlake styles. In fact, Woodruff's own home, aptly known as Woodruff House, served as the crown jewel in the new district.

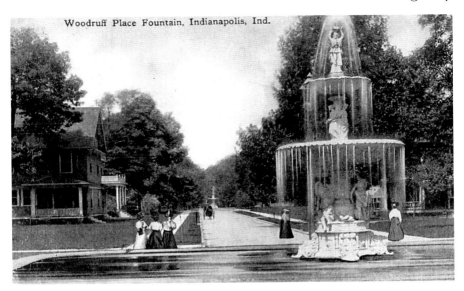

Woodruff Place Fountain, Indianapolis, Ind.

The Woodruff Place fountains added a water element to the neighborhood in addition to their artistic and cultural flair. *Courtesy of Bruce Burton.*

Woodruff's vision was to create an oasis that residents could enjoy, but the Financial Panic of 1873 prevented him from realizing the economic reward he sought in his new town. There was much speculation in those early days—lots were bought and sold numerous times before the land was eventually developed. Woodruff himself never realized his dream of seeing his neighborhood completed. The panic took its toll on the founder of Woodruff Place, and he was forced to sell his grand home and move away. He relocated to New York, where he died in 1879.

As the economy improved, those who survived the panic slowly carried Woodruff's vision forward. By 1880, the population of Woodruff Place was twenty, and in the following decade, it increased by nearly tenfold. Many prominent citizens called Woodruff Place home over the years. In fact, Booth Tarkington's Pulitzer Prize–winning *Meet the Ambersons* was set in a fictional neighborhood of high-society residents resembling those of Woodruff Place, and it is rumored that Lew Wallace put the finishing touches on *Ben-Hur* while living in this exclusive community. Indiana artist T.C. Steele painted many scenes depicting Woodruff Place around the turn of the century, and Colonel Eli Lilly coined the term "Woodruffian," based in the autonomous nature of those who resided in the quiet neighborhood. Even Hoosier poet James Whitcomb Riley couldn't resist capturing the grandeur that was Woodruff Place in those early days. In his *Complete Poetical Works*, Riley composed "June at Woodruff":

Out of Woodruff Place-afar
From the city's glare and jar,
With leafy trees, instead
Of the awnings overhead;
With the shadows cool and sweet,
For the fever of the street;
With the silence, like a prayer,
Breathing round us everywhere.
Gracious anchorage, at last,
From the billows of the vast
Tide of life that comes and goes,
Whence and where nobody knows—
Moving, like a skeptic's thought,
Out of nowhere into naught.
Touch and tame us with thy grace,
Placid calm of Woodruff Place.

As the nineteenth century came to a close, railroad traffic and an industrial boom meant that more and more people of means were drawn to the quiet charm of Woodruff Place. Between 1898 and 1910, most of the suburb's homes were constructed representing a variety of architectural types such as Queen Anne, Eastlake, Neo-Jacobean, Victorian, Edwardian, Classic, Colonial Revival, Bungalow and American Foursquare. For the most part, these homes were designed as single-family dwellings, but by the second decade of the twentieth century, there was a demand for rental properties, and several duplexes and small apartment buildings joined the landscape.

Dorothy Dugdale's family moved to Woodruff Place in 1901. Her father, Benjamin Dugdale, bought several lots in the neighborhood in the late 1800s before building the family home on East Drive. Through the Edwardian era, Dugdale remembered with fondness her life in this unique part of the city in her memoir, *My Rear View.* She describes living three doors down from Brandt and Helen Steele, the son and daughter-in-law of T.C. Steele, and next door to photographer William H. Bass. Taking readers on a tour of her family's home, which was very typical for the time period, with the exception of the very rare second bathroom to accommodate six children, Dugdale portrays a life that might seem primitive to those growing up in the latter part of the twentieth century. From shoveling coal into the basement furnace to listening for the Rag Man and watching her mother barter with Salvador Dargo, who brought fresh fruits and vegetables to the door, Dugdale said that each day in Woodruff Place was exciting.

"There were few automobiles in those early days and many deliveries which came to our door were made by horse and wagon," she wrote.

Perhaps our happiest time was when Mr. Taflinger, the iceman came… After he secured his horse with a heavy weight, he'd climb up onto the wagon, remove the tarpaulin that covered the ice…He would chip away at the ice, secure our piece with heavy tongs and carry it to our icebox, which was on the back porch.

Of course, the minute the iceman left his wagon unattended, the children climbed aboard looking for any ice chips that could provide a cool summer treat.

"The floor of the wagon was never clean, there were pieces of straw… [but] we never seemed to pick up any germs," Dugdale recalled.

However, families couldn't get every necessity from a horse and buggy. There was a host of local storefronts, such as the drugstore, dry goods store and hardware store, on Tenth Street (once known as Clifford Avenue), just a few blocks from the Dugdale home. For special occasions, a trip on the streetcar (or later, an automobile) might be required for a journey to Wasson's, Blocks or L.S. Ayres.

Dugdale attended John Greenleaf Whittier Elementary School No. 33 on Sterling Street and spent a lot of her after-school time playing in the Woodruff Place fountains and shooting marbles with the neighborhood kids.

"We were not so burdened down as so many youngsters are nowadays with many after-school activities…We created our own after-school activities, all cheap, and all a lot of fun," Dugdale recalled.

Though the Woodruff Place neighborhood thrived in its early years, eventual out migration to the Meridian Kessler area on the Northside negatively impacted the Eastside suburb. Some of the setbacks included the popularity of the automobile, World War I and the Depression. Along with the city's expanding industry and increasing population, the once grand, affluent, single-family homes were divided into apartments to meet housing needs, and the once wealthy citizens who occupied the homes were replaced by blue-collar workers.

As more and more people flocked to the new suburbs after World War II, Woodruff Place saw its largest population in the 1950s, with fifteen hundred people who called the neighborhood home. Still, the community experienced a decline as it gained the reputation for being an "inexpensive place to live near downtown that had big, old mansions," according to the Woodruff Place website. In 1962, the final insult came when Woodruff

Place was annexed into Indianapolis and lost its autonomy as a community unto its own. Once a part of the city, some of the statues and urns that were trademarks of the neighborhood were damaged by storms, auto accidents and vandalism and ultimately were not repaired by the city.

Still, those who lived in Woodruff Place saw a great deal of potential for the urban redevelopment of the Eastside neighborhood. Dedicated residents uncovered the history of Woodruff Place, and thanks to their diligence, in 1972 the community was added to the National Historic Register.

Today, those who live in the Woodruff Place community have an appreciation of the past and a desire to return the neighborhood to its former grandeur. Residents are a tightknit community who work hard to maintain the vision that Woodruff himself sought to achieve more than a century ago. The Woodruff Place Civic League boasts a membership that holds various fundraising activities such as the Annual Flea Market, Victorian Home Tour and Children's Halloween Party. The twenty-first century has already seen many restoration and preservation initiatives in the area that have resulted in the rise of real estate values. Woodruff Place is now a historically protected neighborhood under the Indianapolis Historic Preservation Commission, and it draws a variety of people who seek to make their homes in a quiet neighborhood just minutes from downtown.

"The clearly defined boundaries and its status as a self-governing town for eighty-plus years fostered a sense of community that continues to this day," said Cook. "Whereas other neighborhood associations on the Near Eastside defined their boundaries and chose a name decades after the homes were built, Woodruff Place has held onto its identity since its founding."

Arsenal Technical High School

In 1861, not long after the onset of the Civil War, Governor Oliver Perry Morton decided it was his responsibility to establish a state arsenal in Indianapolis. The seventy-six acres just east of the city were purchased on July 11, 1862, for $35,000 and were to be used for the deposit and repair of arms and munitions for war. The original state arsenal was closed on April 8, 1864, when the national government took over all munitions work and began to improve the site for future use. The buildings that were part of the original arsenal included the main residence, an office building, an artillery building and a powder magazine. The barn, west residence, guardhouse, gateway and workshop were constructed between 1869 and 1893 using the best of materials, including pressed brick and Vernon limestone. Great

care was taken to ensure that the arsenal grounds had trees and gardens, and these were maintained by an expert landscape supervisor. Additional shrubbery and flowers were planted at various locations in order to beautify the grounds.

According to *The Story of Technical High School*, there were thirteen different commanding officers during the time that the arsenal was in use, along with a constabulary of fifty soldiers, heavy artillery, lighter arms and a limited amount of ammunition, but by the early 1890s, there was a trend to abandon arsenals throughout the United States in favor of other military posts. In fact, by 1902, the War Department made it known that it planned to deactivate the arsenal and establish its military operations at the new Fort Benjamin Harrison, which was to be located on a larger tract of land northeast of Indianapolis (today, the city of Lawrence). It listed the arsenal real estate and its appointments for sale, asking $154,000.

A great demand was made in the city by various residents and civic organizations that wanted to see the arsenal grounds kept intact and used either as a public park or as a site for an academic institution. A fundraising campaign followed, with donations pouring in from the private sector, which wanted to buy the site and use it for an arts and trade school that was to operate under the auspices of the Winona Agricultural and Technical Institute. As many as four thousand donors came forward with funds, and on March 27, 1903, the property was sold at auction and the deed was given to the public trustees, who were to hold the property in trust until the rest of the funds could be secured.

In 1904, the Winona Technical Institute at Indianapolis was created, with the proviso that when the school secured an endowment that would guarantee that it would be self-sustaining, the trustees of the site would turn over the deed to the institution. But in 1909, an investigation into Winona found that the school was completely insolvent, no endowment had ever been created and there didn't seem to be one on the horizon. Several claims against the school were leveled, and the Board of School Commissioners of the City of Indianapolis came forward to say that it was willing to establish a technical school on the arsenal site in accordance with the trust agreement.

A period of litigation that went all the way to the Supreme Court of Indiana soon followed to determine who was entitled to develop the land. The lower court ruled in favor of the Board of School Commissioners, and the Supreme Court upheld the decision on May 22, 1916. While the litigation was ongoing, Winona Technical Institute remained operational, but ultimately, the property ended up in the hands of the commissioners, who were authorized to establish a vocational high school on the site using $450,000.

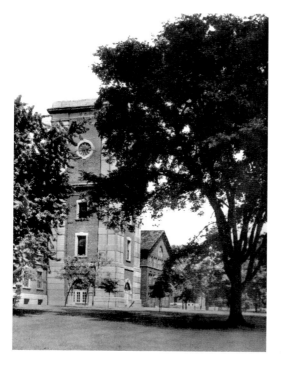

The bell tower at Arsenal Technical High School in 1939. The institution sits on the site of the old Indianapolis Arsenal. *Courtesy of the Arsenal Cannon, 1939.*

By 1912, overcrowded conditions at both of the city's secondary schools—Shortridge High School and Emmerich Manual Training School—had made the need for expansion immediate, but the Board of School Commissioners did not own enough property adjacent to either school to build an addition that would alleviate the problem. There also wasn't enough time to purchase property and build a completely new school. The only solution that made sense was to find a location to which enough students from both high schools could be transferred and where new students could be accommodated as well. The board wanted parents to be assured that students would receive the level of education that they had come to expect at the other locations, and the only site that seemed ideal was the grounds at the former arsenal.

It was clear that the arsenal grounds provided a central location that would accommodate many public grade-school graduates who lived closer to the grounds than to either of the other two high schools. Their choice to attend a school closer to home would significantly reduce the number of students at the other schools out of convenience alone.

In addition, there were already buildings constructed on the grounds and plenty of landscaping that gave the property an aesthetic quality only

found on college campuses. With all of these positives, the superintendent and school commissioners felt justified in announcing that the new high school would take the overflow from Emmerich Manual Training School in September 1912.

Though it began as an offshoot of another institution, it was clear that the Technical High School possessed a history of its own. In old records of the purchase, it was intimated that the land was originally inhabited by Native Americans.

The Story of the Technical High School reads:

> *The old trees carefully preserved by the government authorities are replete with suggestions of aboriginal Americans, of the stirring events in the Northwest Territory, and of the important incident in the settlement and early development of Indiana. In the forefront of this historical background, the buildings erected by the Federal Government stand as monument to commemorate the loyal devotion of Indiana to the cause of the Union into the great conflict of the sixties. They speak, too, of the engagement with Spain in the nineties, for in these buildings some of the equipment for the war was manufactured.*

A total of 183 students were ready for the scheduled opening of Technical High School's first academic year on September 12, 1912, only to find it delayed by a few days. Construction work and carpentry projects had not been completed at the building, and there were no desks, books or school supplies for the students. Though it must have come as a big shock to the students, none of them was dissuaded from returning to the new building on September 17. The boys and girls accepted the situation in the spirit of leaders and realized that anything worth being a part of might have a few setbacks along the way.

Eight teachers opened the Technical High School's doors, including Hanson H. Anderson, Marie K. Binninger, Clarence Hanna, Elizabeth M. Jasper, Emily McCullough, Ester Fay Shover, Osmond Spear and R.V. Yenne. While the fate of the new school was still before the courts, no additions could be planned, making every term during the first four years difficult to endure. Students and faculty had to eat lunches at home or in the crowded lunchrooms, while long days meant that there was no time for conference periods or after-school activities. The PTA and student clubs were curtailed for a while, and temporary improvements in the building meant that everyone had to make some concessions in order to help the school thrive in those early years.

But thrive it did. By the end of the fourth year, enrollment was up to fourteen hundred, and the faculty was dedicated to the new institution. Using equipment installed during the Winona Institute days, the Technical High School was able to distinguish itself further and was given official recognition for offering six courses known as practical vocational. This distinction earned Tech aid from the state. Over the years, the vocational curriculum included machinery, printing, carpentry, sheet metal, tool grinding and others that would give students a trade they could use after graduation. Today, these programs remain a part of Tech's curriculum.

Eventually, Tech was able to add extracurricular activities to its table of offerings, and in 1916 (once the courts made it clear that the land could be used for city school purposes) the athletic program included tennis, along with baseball, track, basketball and hockey. Choruses and other clubs were soon added, and from the school's beginning, a student-run newspaper was supported.

"It was a wonderful place to go to school," said Shirley Phelps, a Technical High School graduate. "They offered so many courses, and it was easy to walk there from my home on Beville."

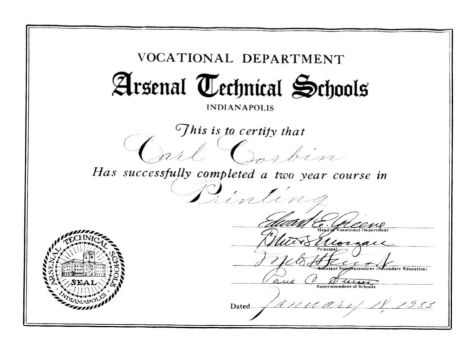

Carl Corbin's printing certificate from 1933 showing that he completed Tech's two-year program. *Courtesy of Diane Roudebush.*

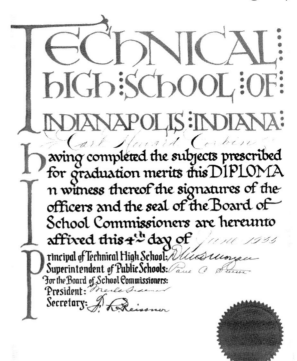

TECHNICAL HIGH SCHOOL OF INDIANAPOLIS INDIANA

Carl Howard Corbin

having completed the subjects prescribed for graduation merits this DIPLOMA In witness thereof the signatures of the officers and the seal of the Board of School Commissioners are hereunto affixed this 4th day of

Principal of Technical High School:
Superintendent of Public Schools:
For the Board of School Commissioners:
President:
Secretary:

Carl Corbin's Tech diploma from 1935 showing that he completed all of the school's requirements for graduation. *Courtesy of Diane Roudebush.*

Her husband, Rodney, also graduated from Tech and said he used to play in the concert band for the school. When he graduated in 1938, there were twelve hundred students in his class.

"We had to play for the graduation ceremony at Butler University," he said. "As the class marched in, we had to play the entire time. It took a while."

Despite the early issues, Tech remains a force on the Eastside for academic and vocational opportunities. Core curriculums, along with various opportunities to learn trades, afford students a well-rounded educational program that will help them seize their futures.

Fountain Square

For South Eastsiders, Fountain Square is a unique commercial district that offers residents a combination of retro style and urban chic. Of course, it didn't start out that way. In 1835, a 264-acre farm plat that belonged to Dr. John H. Sanders was purchased by Calvin Fletcher and Nicholas McCarty, who wanted to lay out the southeast area of Indianapolis in "town lots." The

acreage included what is known today as Fountain Square, and although many people think of the Fletcher family as being one of the first settlers in the area, a group of Delaware Indians lived at the site of the Abraham Lincoln School No. 18 (on what is now Palmer Street) as late as 1820.

What began as a sparsely populated residential area changed in the 1860s with the arrival of the Citizens Street Railway Company, which laid tracks down Virginia Avenue and constructed a turnaround at the intersection of Virginia, Prospect and Shelby Streets. Locals nicknamed the neighborhood "the End." People began flocking to the area, and the neighborhood began to experience rapid commercial growth. Fountain Square attracted a number of Irish immigrants, along with a smattering of folks from the East and Upland South, establishing the culture of the community. In fact, the presence of Saint Patrick's Catholic Church, built in 1865, is a tribute to the Irish population in the vicinity.

By the 1870s, the growth of the Fountain Square area required re-platting the neighborhood eight times. It was during this time that the German immigrants became more visible in the district, and by the end of the century

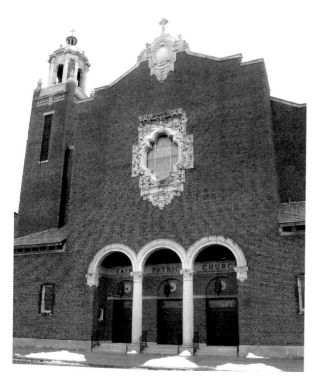

Saint Patrick's Catholic Church in Fountain Square, on the South Eastside of Indianapolis. *Author's private collection.*

the neighborhood had developed a distinctly German character while still retaining its diversity.

"It was an interesting mix," said Charles Montgomery, who grew up in the Fountain Square community. "Basically, the southeast side was settled by Germans, Italians, Jewish folks, Slavic people and others with diverse ethnic backgrounds. It was a unique setting, but everyone got along."

Various schools and churches were erected throughout the neighborhood as more and more working and enterprising people turned to this bustling area of town to establish their homes and set up commerce. Emmerich Manual Training High School opened in 1895, and in 1896 the third branch facility of the city's library system opened in Fountain Square at Woodlawn and Linden Streets. Businesses, such as Charles Yorger's Meat Market, the Fountain Square State Bank, Standard Grocery and the Frank E. Reese Company, also thrived in the community.

Fountain Square continued this trend of prosperity throughout the first three decades of the twentieth century. Garfield Park became one of the cornerstones of the community as part of the city's initial park system designed to link downtown with the outlying areas. The pagoda in the park, built in 1903, as well as the sunken gardens, reflected landscape architect George Kessler's touch, and the park became home to many May Day celebrations, dances and other large community events. Live performances in the neighborhood eventually segued into a building project that lasted for two decades and turned Fountain Square into the city's first theatre district. According to the Polis Center's website, between 1909 and 1929, eleven theatres were built in the community, including the Fountain Square Theatre (1909), the Airdome (1910), the Sanders Apex (1914) and the Granada (1928). The second Fountain Square Theatre was built in 1928 as well.

In 1919, the first "Subscription Fountain" was removed unintentionally when a local merchant tied one end of a banner advertising a sale at his store to the fountain and the other end to his business. A wind kicked up, and the banner's weight ultimately toppled the fountain and its statue. Mayor Samuel "Lew" Shank believed that Fountain Square would benefit from the installation of a new fountain, so a donation was obtained through a bequest to the city from the will of Phoebe J. Hill and named in memory of former congressman Ralph Hill. The new fountain, complete with the bronze statue of a pioneer family sculpted by Myra Reynolds, was unveiled in 1924.

Montgomery remembers the glory days of Fountain Square in the 1940s. He said that his parents were among the working-class people who came to define the area—his father worked as a printer for a number of local newspapers, and his mother took odd jobs in the local market or drugstore to

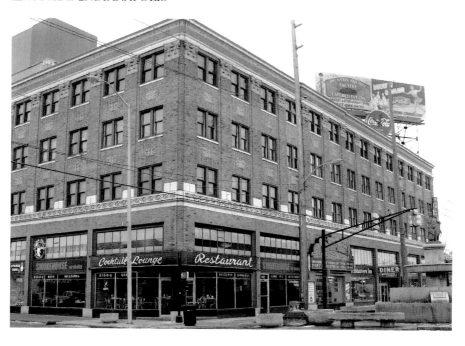

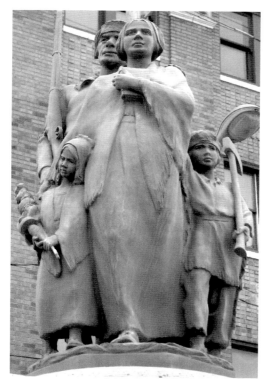

Above: The Fountain Square Theatre building has been restored over the years and is now home to several restaurants and recreational facilities. *Author's private collection.*

Left: The pioneer family statue sits atop the Fountain Square "fountain" in front of the Fountain Square Theatre building. *Author's private collection.*

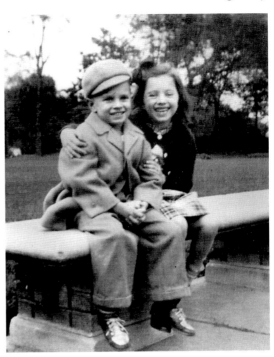

Jeff and Sandy Johnson in Garfield Park, 1948. Garfield Park has provided many childhood memories over the years. *Author's private collection.*

bring in extra money for the family. A graduate of Abraham Lincoln School No. 18 and Manual High School, Montgomery said he has very happy memories of hanging out with the neighborhood kids at Ringgold Park, the alley beside his house, and at the Fountain Square Theatre building.

"I loved living there," he recalled.

> *Everyone who was anyone went to the Friday night shows and swimming at Garfield Park. We had three movie theatres, five dime stores, a bowling alley and the legendary Tucker Drugstore. You knew you came of age when you got to work for "Tuck" and be one of his boys.*

The post–World War II era marked the beginning of the economic decline in the Fountain Square neighborhood. New developments being built farther south diminished Fountain Square's long-standing role as the commercial epicenter of the South Eastside of Indianapolis. Theatre closings followed, and most of the established businesses closed or relocated as many of the residents with long traditions in the community moved away. In 1954, Fountain Square's "fountain" was relocated to Garfield Park, a symbolic acknowledgement of the neighborhood's decline.

The Jonestown Connection

Commercially, the Fountain Square neighborhood was declining, but the schools and churches in the area remained vibrant. School programs were getting national recognition, and new clubs and organizations were being formed to accommodate changing interests. Not long after the Fountain Square Church of Christ moved into its new location at Spruce and Prospect Streets, the Laurel Street Tabernacle established a new facility on Laurel. Within three years, Reverend James Warren "Jim" Jones, a former associate pastor of the Laurel Street Tabernacle congregation, created his independent organization, the Community Unity Church, at Hoyt and Randolph Streets.

Jones was a charismatic preacher born on May 13, 1931, in Lynn, Indiana, to James Thurmond and Lynette Jones. His father was an unemployed alcoholic Klansman who had spent five years in a mental hospital and ultimately tried to make a living as a mystic fortuneteller. As a young child, Jones was deeply religious and attended several churches in eastern Indiana. He ultimately graduated from Butler University in 1961 with a degree in secondary education.

In order to fund his new church, Jones not only continued his role at the Laurel Street Tabernacle but also sold live monkeys door to door (his

The Fountain Square Christian Church was one of many religious organizations in the neighborhood. *Courtesy of C.O. Montgomery.*

advertisements ran in the *Indianapolis Star*) to people such as Edith Cordell. Using his salesmanship, he would invite his clients to church. The church flourished, and soon the congregation moved to a new location on North New Jersey Street, calling itself the People's Temple.

"Jim was breaking new ground in race relations at a time when the ground was still really hard against that," said Reverend Garnett Day in the documentary *Jonestown: The Life and Death of the People's Temple.*

"It didn't make no difference what color you were," said June Cordell, daughter of former temple member Edith Cordell, in the documentary. "Everyone was welcome and he made that plain from the platform."

The People's Temple was a highly productive organization, setting up soup kitchens and giving away clothes and food to the poor. Jones's theology was deeply rooted in social justice and racial equality. He even established two nursing homes during his stint on the Eastside. Then, in the early 1960s, Jones claimed that he had an apocalyptic vision that the Midwest would fall victim to a nuclear attack. He decided to move his flock to California, where they continued to live out their utopian dream, never realizing that they were immersed in a dangerous cult. Ultimately, the movement relocated to Guyana, South America, where, on November 18, 1978, more than nine hundred of Jones's followers and residents of Jonestown were forced to drink cyanide-laced Flavor Aid and lay down their lives for Jones in what was called the largest mass suicide in human history. Jones died of a gunshot wound to the head.

Revitalization Efforts

As for Fountain Square, the 1960s and '70s weren't kind to the neighborhood. Interstate highway construction of the "Inner-Loop" of portions of I-65 and I-70 through Indianapolis displaced seventeen thousand residents, and one of the hardest-hit areas was Fountain Square. Over six thousand people, or 25 percent of the residents in the neighborhood, were forced to relocate due to construction. Slashing through the near Southside, the highway separated Fountain Square from other neighborhoods such as Fletcher Place.

"It's just my opinion of course, but for whatever reason, it seemed that the city fathers at that time turned their back on Fountain Square," Charles Montgomery said. "Apparently, at that time, the square did not have enough clout to be viable to the city."

Still, there was the belief that Fountain Square had something to offer, and many residents and business owners in the area sought to revitalize the community. The biggest example of this new phase in the community was

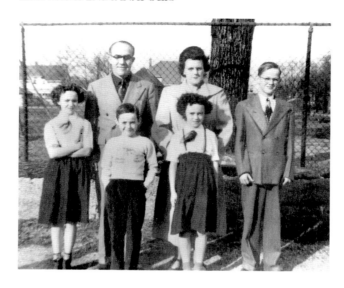

The Montgomery family stands in front of Ringgold Park, which was significantly reduced in size by the construction of the "Inner Loop." *Courtesy of C.O. Montgomery.*

the reinstallation of the Fountain Square "fountain" in 1969. Neighborhood organizations such as the United Southside Community Organization (USCO), the Southeast Multi-Service Center and the Fountain Square's Merchants Association banded together to establish the Fountain Square Consortium of Agencies in 1978. Thanks to these efforts to revitalize, as well as Community Development Block Grant funds and the $3 million that was invested in Fountain Square between 1980 and 1982, the commercial district was placed on the National Register of Historic Places. The Near South Eastside was also designated an urban renewal area in 1983. Today, the community is one of six designated cultural districts in the city.

"I think that the revitalization came about when several folks realized the history involved with Fountain Square and decided to do something about it," Montgomery said.

Today, Fountain Square is a vibrant area of the city, boasting vintage and antique shops, galleries and the restored Fountain Square Theatre building, with a 1950s-style retro diner, a duckpin bowling alley and Friday night swing dances. Fountain Square not only has a future, but it is also clearly honoring its past.

"I am glad to see Fountain Square being revitalized and I do visit often," Montgomery said of his old neighborhood.

Even though the neighborhood has a small boundary, its appeal is far greater than just a few streets. There is just such a rich history there, and it is great that someone had the forethought and money to preserve and restore this district.

NEIGHBORHOODS FOR THE WORKING CLASS

Today, many of the neighborhoods that compose the Near Eastside of Indianapolis stand as shadows of their once industrious pasts. Vacant and rapidly deteriorating homes, along with empty storefronts and silent factories, offer a glimpse of this once vibrant portion of the city as it used to be and show how the ever-eastward push of neglect led to the transformation of this community from thriving working-class neighborhoods into blighted urban inner city.

The Near Eastside

During the Victorian age, when Woodruff Place, Fountain Square, Brightwood and other early residential areas gained popularity on the Eastside of Indianapolis, other neighborhoods were developed in this eastward expansion as well. In 1863, not long after establishing the arsenal, the city designated a portion of the southwest corner of the Highland Brookside area for residential development. Streetcar lines were expanded in order to accommodate these new communities cropping up on the Eastside. In 1870, the city fathers purchased from the heirs of Calvin Fletcher several hundred acres on the Eastside that would eventually become known as Brookside Park. Other parcels of land throughout the area were also purchased, using redeemed Belt Railroad bonds, in the late 1890s and would form the nucleus of the public parks system that fully developed in the new century.

Streets were opened and improved near the arsenal and Woodruff Place, giving access to the Eastside as never before. Woodruff Place had established itself as the commune for well-to-do citizens, but the completion of the Belt Line Railroad in the late 1870s made the Eastside attractive to industries, and the common laborers who were employed nearby wanted to live close to their workplace. Like the Martindale-Brightwood area, the railroads were the livelihood of these workers.

Churches and schools quickly followed the residents and businesses eastward. In 1895, the Catholic Diocese of Indianapolis recognized a need to minister to a number of Irish, German and Italian immigrants now living on the Eastside of town. To meet that need, it established Holy Cross Parish at the corner of Hannah and Springdale Streets, dedicating the new church on August 8, 1865, just four months after construction began. Almost immediately, the church outgrew its space, and a building fund was initiated as testimony to the popularity of the Eastside communities in the latter part of the century.

In order to accommodate the growing number of schools in the area, James Russell Lowell School No. 51 and Lucretia Mott Public School No. 3 were established, along with Holy Cross Catholic School, during the years between 1900 and 1905. Holy Cross bought a new piece of property on the southeast corner of Oriental and Ohio Streets in 1912 and constructed its new home at that location in 1921.

Brookside and Highland Square gave residents plenty to crow about in the early 1900s as public green space offered families room for picnics and other recreational activities. Those looking for an extra thrill would have the addition of the Wonderland Amusement Park at Washington and Gray Streets in 1906—their own little taste of Coney Island on the Eastside of Indianapolis.

Wonderland Amusement Park

In the late 1890s, amusement parks gained a lot of popularity thanks to the mechanized attractions that enchanted visitors at national events like the Chicago World's Columbian Exposition, traveling circus acts and the local motorized park, such as Coney Island in New York. On May 20, 1906, the Wonderland Amusement Park on East Washington Street opened its gates to an eager eight thousand people, but it wasn't the only game in town for long. By the end of the month, two more amusement parks had joined the Indianapolis landscape to compete for dollars, offering an ever-changing array of thrill rides and wonders that served as testimony to the industrial age.

The history of Wonderland began months before the park opened when the Wonderland Construction Company, led by Richard Kann of Milwaukee, Edward H. Rentsch and Minnie E. Wilson of Indianapolis, filed articles of association in 1905. With $200,000 in capital stock, the company planned to purchase the property at Washington and Gray Streets and erect buildings, machinery and landscape that would make up the mechanical marvel on the Eastside.

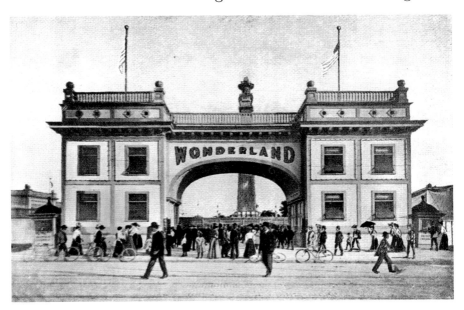

Above: A postcard showing the entrance of the Wonderland Amusement Park, the Eastside's own Coney Island. *Courtesy of Ron Huggler.*

Right: The original map showing the layout of the Wonderland Amusement Park on two city blocks. *Courtesy of Ron Huggler.*

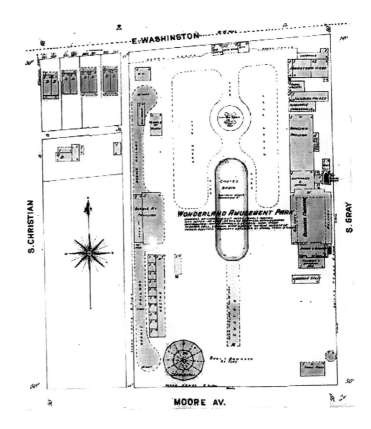

The land chosen for the site of the amusement park was two city blocks that had previously been used as a baseball field. Because the city limits were only a few blocks east of the proposed development, the land around the space was sparsely populated and, for the most part, undeveloped. The park was walled off, though before too long the "scenic railroad" that would take guests into the new fun zone, could be seen rising above the gates, giving passersby a taste of what was to come. The "railroad" was to be 575 feet long, with four interweaving tracks that would take passengers for a ride of a half mile over the park's grounds. Complete with five thousand electric lights, the train cost about $18,000.

In addition to the scenic railroad, Wonderland boasted a 125-foot-tall Electric Tower, and guests of the park (admission was ten cents for adults and five cents for children) were treated to a dramatic spectacle reenacting the 1889 Johnstown flood in Pennsylvania. Sensational stories, complete with painted scenes and unique lighting effects, thrilled audiences as they listened to a narrator describe the realistic-looking flood scene. It quickly became one of the most popular attractions at the park. Other rides also thrilled revelers, such as Loop-the-Loop and Shoot the Chutes Lagoon. The landscaping offered Wonderland visitors beautiful gardens in addition to the noisy machinery. Throughout the property, Wonderland boasted plenty of flora, green lawns and newly planted trees.

Wonderland's buildings were built in a design similar to those seen at Chicago's "White City" during the World's Columbian Exposition of 1893—Beaux Arts symmetrical structures and arched entries with the name of the park proudly inscribed above the arch. The real crown jewel in the Wonderland development was the amount of lights that were used to illuminate the rides, green spaces and buildings. As many as fifty thousand electric light bulbs were used within the park—enough lights to brighten a city of thirty-five thousand people.

The park had to live up to its billing of "Park Beautiful," a nickname given to Wonderland by its management. Every aspect of the park was kept in tiptop shape, primarily due to competition with the two other local amusement parks—White City in Broad Ripple and Riverside on the Westside, each fighting for the public's dollar. Each park feverishly worked to book the latest circus daredevil acts, animal oddities or the free exhibition of the Kann War Airship, which contained an engine designed by Indianapolis Motor Speedway developer Carl Fisher. Other important events included the 1907 Pain's fireworks spectacle, a famous attraction at Coney Island that went far beyond the basic explosions and noisemakers normally associated with fireworks shows at the time. Pain's shows were the latest and greatest in pyrotechnics.

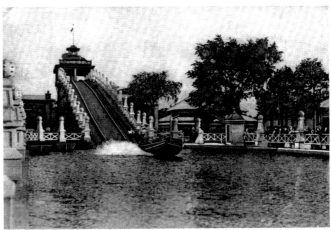

A postcard of the Wonderland ride Shooting the Chutes. With competition from other parks, attractions had to be top-notch. *Courtesy of Ron Huggler*.

"Shooting the Chutes" at Wonderland, Indianapolis.

Despite the amount of money being invested in Wonderland, as well as the two other parks in the city, it was clear that the public could not support all three amusement venues. White City was the first casualty when it was destroyed by fire in 1908. The surge of patrons who came to the Eastside to enjoy Wonderland's attractions after White City's demise was not enough, however, to make the owners feel that they were realizing enough of a profit on the park. In an effort to offer something truly unique, Wonderland's managers decided to announce plans for a German beer garden. This was a racy move considering the park's location to nearby Temperance Avenue and the alcohol-free suburb of Irvington, just a few miles east. When word of the beer garden hit the news, mothers and temperance societies alike gathered to stop Wonderland's plans.

The women were effective. Not only did they convince local newspapers to carry the story about their intentions to thwart Wonderland's beer garden plans, but they also vowed that they would not bring their children to a park where intoxicated patrons might be a negative influence on their children. In addition, the local beer suppliers backed the women out of fear that if they stood up to the mothers, the opposition to the proposed beer garden would hamper their trade in other areas. When the petition ran in the *Indianapolis News* demanding that the park reconsider its plans, Frank M. Wicks withdrew his request for a beer license.

By 1909, attendance at Wonderland slowed to a crawl and the park abandoned its usual schedule, only opening when private groups rented the grounds. Eventually, parts of the park were closed, and in the years following, only the dancing exhibition area was operational. In 1911,

Wonderland's primary customer was the International Interdenominational County Fair, which used fair proceeds to help a local charity designed to assist sick children. The fair was advertised heavily, and the crowds came out in support of the organization, pleased to hear that Wonderland was in good condition and ready to provide wholesome entertainment for the whole family. Wonderland seemed to be back on top until it was hinted that there was an alcohol-related feature in the park: the Blind Tiger. Known in police circles as code for an illegal alcohol emporium, the Blind Tiger was raided on its opening night. When alcohol was not found on the premises, the attraction continued to operate.

The final event for the 1911 season, which would prove to be Wonderland's last, was the Colored Knights of Pythias, which rented Wonderland for its biennial encampment. Throughout the week-long festivities, the park held special events, while Booker T. Washington appeared as the guest of honor. According to *Indiana Amusement Parks 1903–1911: Landscapes on the Edge* by Indiana University student Connie J. Zeigler, the fact that the park was rented to an African American organization is indicative that the park was facing serious financial straits. Many of the amusement parks were segregated at the time, and it is believed that this event, combined with the beer garden incident, cemented Wonderland's reputation as an entity that went, according to Zeiger's thesis, "beyond the limits of acceptance in 1911 Indianapolis."

The encampment ran from August 19 to August 26, but on August 27, an advertisement proclaimed that the park would be opened exclusively for the enjoyment of those in the African American community. After park-goers had enjoyed a busy day of rides and merriment, and after the last of the guests had left, in the middle of the night, Wonderland went up in flames. The night watchman, R.C. Buchanan, sounded the alarm at 1:10 a.m. on August 28, but it was too late. Flames had already gotten to the merry-go-round and other attractions before the first fire truck arrived.

A discarded cigarette was more than likely responsible for the fire, and because the rides were made out of wood, they burned rapidly, just as they had when the White City went up in flames. By 3:00 a.m., many of the buildings and attractions were in ruins, on fire or reduced to cinders. After a few hours, firemen were finally able to extinguish the blaze.

Wonderland company president E.I. Fisher estimated the damage to be between $18,000 and $20,000, and with only $5,000 in insurance, he decided not to rebuild. There was talk of selling the land to another company that would bring in new amusements, but the deal never went through. Those who were present the day after the fire brought their cameras to capture the

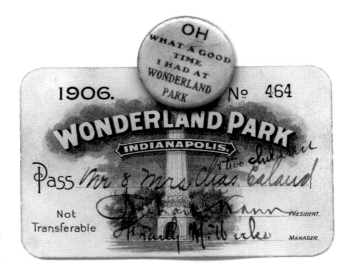

A rare vintage ticket and lapel pin from the Eastside's Wonderland Amusement Park. Souvenirs included postcards, sheet music and other items. *Courtesy of Ron Huggler.*

remains of the once great Wonderland, a last reminder of "Park Beautiful," a place that pushed the bounds of good taste but offered revelers years of mechanical fun. It was the end of an era.

Continued Growth

Despite the loss of Wonderland, the Near Eastside community continued to grow rapidly throughout the 1910s and '20s as more churches, schools and businesses were erected in the area. Families chose to make the Eastside their home, not only because of the close-knit community that resided there, but also to be close to any number of employment opportunities such as John Madden Furniture Company, RCA and P.R. Mallory Company, which opened on the former Wonderland site. Residents also had direct access to the streetcar, which would take them downtown and to the center of everything, a must in those days when not everyone had an automobile at their disposal.

Dorothy Everett, age ninety, grew up on a farm on the Far Eastside of the city, near Cumberland, during the Depression era. A 1937 graduate of Warren Central, she attended the John Herron Art School for two years before marrying and settling in her first home on the Near Eastside at 3512 East Thirteenth Street near Brookside Park.

"We had a car but we sold it in order to get the $500 down payment for the house," she recalled. "My husband was working for Indianapolis Power

& Light during the war years so he didn't have to enlist because he worked for a critical industry."

The couple (later joined by their two children) wasn't hampered by the lack of a car. Everett said that she often rode the streetcar to downtown Indianapolis or walked to the local Standard Grocery Store or other businesses along Tenth Street to get what she needed for her family. It was also common for the milkman to make daily deliveries to reduce shopping trips. In *The Jennifer Letters*, Greg Bierck remembers the days when the Borden's delivery man used to bring milk from the milk processing plant at Tenth Street and Sherman Drive.

"Borden's featured Elsie the Cow in their marketing and I would go meet the milkman at one end of the driveway," he explained.

> *Some days he'd let me get in the truck and we'd drive around the corner, open door and all, over to the other driveway, which might have been a fifty-yard ride or so…could you imagine a four-year-old doing something like that today? At that time, it was a really neat part of the city. We had a pretty little house and all of the kids in the neighborhood played together. For fun, we used to go to the movies at the Rivoli Theatre.*

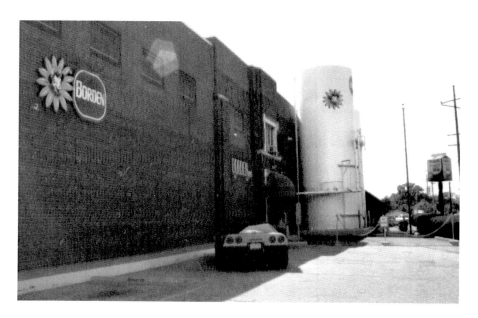

The Borden's Dairy plant near Tenth Street and Sherman Drive provided a variety of dairy products to the Eastside community. *Courtesy of Harold Amonett.*

The Rivoli Theatre

One of the unique gems on Indianapolis's Eastside was the Rivoli Theatre. Built in 1927 with an investment from Universal Studios, the Rivoli was designed to be the crème de la crème of movie houses in Indianapolis. The theatre's location was ideal, too, as it was the last stop on the outbound trolley and the first stop on the inbound trolley. The Rivoli was constructed in a Spanish Mission style with the best materials available, including Indiana limestone, sweet gum woodwork and leaded glass windows. Universal hoped that the theatre would serve the community for a long time as a classy motion picture house providing the best movies Hollywood had to offer.

The Rivoli went all out in terms of luxury, from the ivory lavatory fixtures and intricate wood and plaster grillwork to two organ chambers and flickering "starlight" in the dome of the auditorium. The outside of the theatre had four storefronts that included an ice cream parlor and, according to one of the neon signs, a wax museum at one time.

The Rivoli was considered to be large for a neighborhood movie house. The auditorium could seat fifteen hundred patrons, its stage could accommodate traditional theatrical performances and it had excellent acoustics as well. In fact, according to the Rivoli Theatre's website, famous organist Desa Byrd "found the acoustics to be so extraordinary that she recorded two record albums at the Rivoli." Despite all of the accolades bestowed on the theatre, Universal owned more than three hundred theatres across the nation and the cost to update them all became too prohibitive, so the studio began liquidating the buildings. It sold the Rivoli in 1937.

"We could walk to the Rivoli from our house as well," said Shirley Phelps, who now lives in Irvington.

We were more likely to go to the Hamilton Theatre, which was a little less expensive than the Rivoli, where it cost a quarter to get in and a nickel for your popcorn. Of course, that doesn't seem like a whole lot by today's standards.

The theatre lived on beyond its tenure with Universal. Saturday matinees made the Rivoli a popular spot during the war years, and many enjoyed the Eastside theatre when it was merely the neighborhood movie house. Though the building changed hands many times over the years, the Rivoli continued to be a significant entertainment venue for the Eastsiders, whether as the place where they saw a major motion picture or where they enjoyed live performances by John Mellencamp, Bruce Springsteen, Gloria Swanson,

Bette Davis or Quiet Riot. Throughout the twentieth century, until it closed in 1992, the Rivoli was known for being eclectic, from the live performers who graced its stage to the shimmering images cast upon its screen.

After failed revitalization attempts in 2004, the Rivoli Theatre changed hands again. The Rivoli Center for the Performing Arts, a nonprofit organization, hopes to renovate the theatre, which has suffered from water damage and many years of neglect.

"The question is [how much of an] investment will be needed to bring the building back," said Tammi Hughes, executive director of the Tenth Street Civic Association, in an *Indianapolis Star* article. "If we were to restore it as it was back in its heyday as a building, you're talking about something that's expensive."

A Shift in the Area

Changes in the Near Eastside neighborhoods began just after World War II veterans began returning home. Though many of them chose to secure housing in a familiar area, others were interested in using their GI loans to move into the new prefab models being constructed beyond the Highland-Brookside area. At first, the shift wasn't noticeable. There were still enough middle-income families living in the Brookside area to prevent change from happening overnight. The Brookside Masonic Lodge offered local men a fraternal organization to join, and the city parks department was instrumental in offering community programs and events at the Brookside Park Community Center or on the park grounds.

"I remember when I visited my grandfather, who lived over in that area," said Bruce Madinger. "At that time, there were a lot of the GIs living over there, and he knew everyone. He would always point out who lived in what house, and he knew where they all served. There was that sense that they all had a common ground."

Madinger said that the neighborhood was created long before big department stores at suburban malls put the small mom and pop shops along Tenth Street out of business.

"Those who had enough money to move their stores or leave the neighborhood and [go] into the new suburbs did," he said.

That was certainly true for Everett, who purchased her grandfather's home on the Far Eastside and moved away from the Brookside area to a lot with thirteen acres near Cumberland. By the mid-1950s, the change in the neighborhood was hard to hide, and in an effort to cut some of the

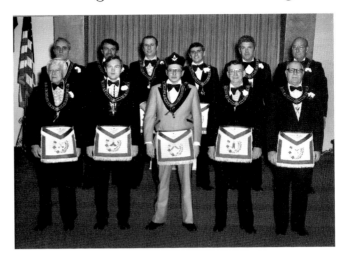

The 1978 Brookside Masonic Lodge officers pose for their installation photo. The lodge is located on Nowland Avenue. *Author's private collection.*

city budget, the Indianapolis City Council opted to sell Highland Park in order to construct a new recreation area on Market Street. Similar to the beer garden battle at Wonderland many years earlier, community members strove to save the park by gathering signatures on a remonstrance, and a ten-person delegation championed the case to the local media and met with city officials. In the end, Highland Park remained open, and the city was persuaded to invest $20,000 in new facilities and equipment for the green space to keep Highland on par with other city parks.

It was only a matter of time before the Near Eastside community had to face the facts—the scenery was changing and the neighborhood was quickly suffering the fate of other inner-city areas. Churches, businesses and homeowners were leaving, and in their wake were vacant properties that quickly deteriorated. The decade of the '60s brought with it a time of turmoil for the nation, as well as the Near Eastside, and in 1965, the murder of a sixteen-year-old girl cast a pall on the prestige of the working-class neighborhood.

The Sylvia Likens Murder

The murder of sixteen-year-old Tech High School student Sylvia Marie Likens has been called the worst crime ever committed against a single person in the state of Indiana. The middle daughter of Betty and Lester Likens was born on January 3, 1949, between two sets of twins, Diana and Daniel, born in 1947, and Jenny and Benny, born in 1951. The Likenses

were carnival concession workers who often traveled for work and, due to the instability of their marriage, separated from time to time. In the late summer of 1965, Lester and Betty planned to travel on the carnival circuit once more, taking their young son with them. Their two oldest children were already living on their own, leaving just Sylvia and Jenny to be cared for while they were away.

Lester befriended a local neighborhood woman known as Mrs. White, who lived on East New York Street. Her real name was Gertrude Baniszewski. She was the single mother of seven who took in laundry or ironing to make ends meet and occasionally baby-sat for families in the neighborhood. Sylvia was friends with Baniszewski's daughters, and when Gertrude heard about the Likenses' plight, she offered to board the girls for twenty dollars a week.

Lester accepted the offer, never inquiring about the conditions of the home where his daughters would be living. It was later determined that the only cooking surface was a hot plate, there were only three spoons to feed the entire family and there were not enough beds for everyone living in the house. The only admonition Likens made to Baniszewski was to use a firm hand with his daughters, as their mother allowed them to run wild. Baniszewski took that instruction to heart.

The first week went by without incident. Those who knew Sylvia knew her as a girl who loved the Beatles and often returned pop bottles for money. She sometimes did ironing or baby-sitting for extra cash. There was no indication that Sylvia or Jenny were the wild children their father made them out to be, but when the boarding payment was late early in their stay, Baniszewski took her anger out on the daughters, ordering them to lay on the bed while she spanked their bare bottoms.

The abuse escalated over the next few weeks. Sylvia was called slovenly when she ate too much at a church supper; Baniszewski labeled her as dishonest, unclean and sexually active (though there was no indication of the latter in the subsequent investigation). Neighborhood kids joined in on the torture, hitting, kicking and otherwise beating Sylvia or extinguishing their cigarettes on her skin. (Jenny was spared the torment, though she was told that if she complained to the police or anyone else, she would receive the same treatment.) When their older sister, Diana, visited the girls one day, Sylvia and Jenny reported the abuse that was going on in the home, but the complaint fell on deaf ears.

Reports later suggested that at least a few people in the neighborhood knew that something unusual was going on at the Baniszewski home. When Phyllis and Raymond Vermillion saw Sylvia with a black eye, given to her by Baniszewski's daughter Paula, they decided to look elsewhere for a baby-

sitter, but they did not file a report with the authorities. A health department nurse was dispatched to the home after a report was filed that there was a young girl living there with open sores. When Baniszewski heard about the complaint, she told the nurse that the girl was a prostitute and had run away. The nurse didn't follow up and the abuse continued.

In October, Sylvia was desperate for a gym suit to wear for class at Tech. With no money for the uniform, she stole one from the school. When Baniszewski discovered that Sylvia had taken the item, she held a lighted match to the girl's fingers and subjected her to yet another beating in order to cure her of her ways. Her alleged promiscuity continued to be a sore subject with Baniszewski, and on at least two occasions, Sylvia was made to masturbate with a soda bottle for her group of tormentors. It is because of these incidents and a lack of sexual abuse that the case has often been referred to as the "sexless sex crime." Sylvia was kept locked in the basement of the home on East New York Street and was often starved or given soup to eat with her fingers. In the most heinous act of the case, Baniszewski instructed the others to "brand" Sylvia by burning into her stomach "I am a prostitute and proud of it."

Near the end, Baniszewski suspected that the girl might die, and she devised a plan to dump Sylvia's body in a local lot after she forced her to write a letter to her mother and father outlining her supposed "deviant" behavior. Sylvia did attempt to run away during her last days, but due to her injuries, she only made it as far as the front porch before she was brought back inside and beaten again. The night before she died, neighbors reported hearing the girl banging on the floor of the basement (with a shovel), but no one called the police.

The following day, October 25, 1965, Sylvia was taken upstairs and placed in the bathtub. When it was discovered that she was no longer breathing, Baniszewski instructed one of the boys to call the police from a nearby pay phone. The authorities arrived, only to be handed the note that Sylvia had written to her parents. This was Baniszewski's effort to exonerate herself of Sylvia's death, but Jenny came forward and told the police that if they got her out of the home, she would tell them what really happened.

When Jenny's story was told, ten people were arrested in the murder, including Baniszewski, three of her children and several juveniles from the neighborhood. Baniszewski claimed innocence. She told authorities that the children had committed the crime and she didn't know that anything unusual was going on. The trial began in May 1966. Lesser sentences were handed down to the young people involved in the crime, but Baniszewski received a first-degree murder conviction and was sentenced to life in prison. Twenty

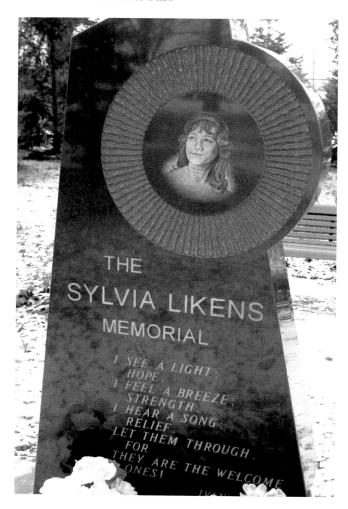

THE
SYLVIA LIKENS
MEMORIAL

I SEE A LIGHT.
HOPE.
I FEEL A BREEZE.
STRENGTH.
I HEAR A SONG.
RELIEF.
LET THEM THROUGH.
FOR
THEY ARE THE WELCOME
ONES!

The Sylvia Likens
Memorial stands
in Willard Park as
a reminder of the
terrible murder of a
sixteen-year-old girl.
Author's private collection.

years later, she was eligible for parole, and despite opposition from numerous parents' organizations, on December 4, 1985, Gertrude Baniszewski was a free woman. She admitted to feeling some remorse for the crime but never confessed to the murder. She died in 1990 in Iowa, living under the name Nadine Van Fossen.

The case of Sylvia Likens has been retold in numerous books and adapted for movies, most recently *An American Crime* by Hoosier film director Tommy O'Haver. It is the Eastside crime that still intrigues those who pass by the recently razed property at 3606 East New York Street and all who visit the six-foot Sylvia Likens Memorial in Willard Park at State and Washington Streets.

The Rise of NESCO

By the late 1960s, the downturn on the Near Eastside encouraged the city to study the Highland-Brookside area. Through the resulting discussions with and surveys of the neighborhood residents, it was discovered that the community was facing serious problems, including dilapidated houses, confusion over land use, a rise in the area's crime rate, racial tension and an increase of residents' dependency on public assistance.

In order to combat the issues, Father James Byrne from Holy Cross Catholic Church, as well as other members of the Eastside clergy, established the Near Eastside Community Organization (NESCO) in 1970. The purpose of the umbrella group was to coordinate activities among the smaller neighborhood organizations throughout the community in order to establish and strengthen social services for those people living on the Eastside. Among the social service organizations established under this umbrella were the Area Youth Ministry, designed to bring hope and faith to teens and young children, and the Near Eastside Multi-Service Center, today known as the John H. Bonner Community Center on East Tenth Street.

Thanks to the grass-roots efforts of the community, other entities joined the endeavor. In 1972, the Department of Metropolitan Development requested over $500,000 to begin an urban renewal project for the Highland-Brookside area that would not only clear the worst of the deteriorating homes but would also rehabilitate some of the existing homes of the neighborhoods. That same year, Woodruff Place was added to the National Register of Historic Places, which was a huge boost for the Eastside and made federal funds available to the residents of the neighborhood for home renovations. In addition, a federally funded environmental study determined that that the Near Eastside area rated well as far as the neighborhood environment and was among the best of the near downtown areas studied.

Unfortunately, the Near Eastside continued to lose residents as more people flocked to the suburbs, leaving their former church and school communities behind. Still, NESCO was not to be deterred. Father Byrne and other volunteers were determined to help their neighborhoods fight back. In 1982, the city designated the area a Community Target Area, which offered monies for home improvements, as well as a commitment from the city to make necessary improvements along the streets.

"I lived near Brookside for five or six years after college," said Madinger. "It had turned into a very different neighborhood than it was when I used to visit my grandfather. It just wasn't the same."

By the mid-1980s, fourteen area churches created an ecumenical partnership called the Near Eastside Church and Community Ministry Project, whose goal it was to improve the quality of life for those living on the Near Eastside. The churches stocked food pantries, created outreach efforts for homebound elderly and disabled residents and offered family-friendly recreational activities. Less than fifteen years had passed since its inception, and NESCO residents had a lot to crow about, not only due to their own diligence but also thanks to the support of corporate donations. In 1984, the Aetna Life and Casualty Company, in partnership with the Indiana Mortgage Corporation, donated $650,000 to assist low- to moderate-income homeowners make improvements and spruce up the local housing market.

Throughout the last decades of the twentieth century, NESCO continued its commitment to the Eastside by establishing drug abuse prevention programs, a new park, continued infrastructure improvements and building renovations that created apartments for low-income residents. Those efforts progressed through the early 2000s, during which residents enjoyed a 28 percent reduction in crime and volunteers pledged over six thousand hours in community service, helped to deter foreclosures, raised over $16,000 and kept several residents in their homes. A civic group was also established to organize efforts to revitalize the Tenth Street corridor. With the 2012 Super Bowl coming to the Circle City, it is estimated that the Near Eastside will benefit from other improvements designed to beautify the area and attract new commerce to the community as well.

Just as early mothers' groups and temperance leagues learned that they could effect change by standing together for a common goal, NESCO and other Eastside community partners proved that when neighbors band together in pursuit of a single purpose, they can be a powerful voice for the people.

THE PRIDE OF THE EASTSIDE

The contributions to the Eastside made by the various religious congregations and educational institutions cannot be underestimated. No matter the denomination or affiliation, all are important to the overall growth and development of the area; however, there are some that serve as anchors of the community and remain desirable attractions to new residents, solidifying the neighborhood's impeccable reputation. Little Flower Catholic Church and Scecina Memorial High School are two such institutions.

Little Flower

The story of Saint Therese Little Flower Catholic Church begins in the Roaring Twenties when the nation was enjoying an economic boom and the Eastside of Indianapolis was considered prime real estate for residential development. The Tenth Street corridor was bustling, but the land around Fourteenth Street and Bosart Avenue was sparsely populated, and real estate agents in the area believed that a new church and school would help sell adjacent lots.

In 1921, the Phoenix Investment Company, Security Trust Company and Rosalia Realty approached Bishop Joseph Chartrand with an attractive proposition: they would turn over the land to the archdiocese if he would build a church and school at that location. Chartrand agreed but did not immediately get started building on the property he had purchased for one dollar. However, word spread throughout the Eastside that a new Catholic parish was forthcoming.

Chartrand selected Reverend Charles T. Duffey to found the new parish, which was to be named in honor of Therese Martin, a beatified Carmelite nun from Lisieux, France, who was expected to be canonized soon. When plans for the Little Flower Church were announced on March 13, 1925,

it was to be the first parish in the world named for the woman who would become a saint two months later. Plans for the church included gathering members from other locally established parishes, such as Saint Philip Neri, Saint Francis de Sales and Our Lady of Lourdes.

Duffey met with the locals, who pledged to help get Little Flower off the ground. One of the first events was a fundraising bazaar that was held in downtown Indianapolis and raised $6,000 for the new building. While plans were still being created for the new parish, the church rented a vacant storeroom in the Harry Philips building at Tenth Street and Bancroft Avenue. This room served as a space in which to hold Sunday and Holy Day Masses. The close quarters were less than comfortable, but early members took the cramped conditions in stride.

"We were wedged in at Mass in the Harry Phillips building," recalled Rosemary Cleveland in the fiftieth-anniversary commemorative parish history book. "Those near the front were often asked to pass the collection basket."

Initially, seventy-five families made up the Little Flower parish, and not only were they eager to see the church constructed, but they also wasted no time in organizing clubs and associations that still serve the parish, including

The Harry Philips building where the Little Flower Catholic Church originally celebrated Mass in the 1920s. *Courtesy of the Little Flower Catholic Church.*

the Men's Club and the Ladies' Altar Society. These groups were committed not only to the church but also to the neighborhood and were constantly raising money through local events such as bingo, fish fries and card parties. Sealed bids were accepted for the contract to build the church and school, and although the lowest bid was $130,000, still more than the parish planned to spend, ground was broken on September 30, 1925.

Construction was slow due to heavy rains, but the parish was not to be deterred. Father Duffey moved into the makeshift church on Tenth Street in February 1926 and arranged for a statue of the newly canonized Saint Therese to be made. He also acquired relics of the nun during a pilgrimage to her convent in France that would be housed in the new church. Daily Masses were being held at the storefront church while the new building was being erected.

Many changes were coming to the neighborhood as well. Streets were paved and electric lights were installed, and while these changes were considered to be a good thing for the area, few homes were being built around the new church. There was still some concern that people would not gravitate to the new parish.

On September 12, 1926, the dedication Mass was held in the church with one thousand people in attendance. There was only seating capacity for about eight hundred in the space (today the area is the school gymnasium). Within a week of the dedication Mass, six sisters from the sisters of Saint Francis, Oldenburg, moved into the top floor of the building, which served as a convent. Within two days of their arrival, the school term started, and the sisters began to oversee the education of eighty-five children.

It wasn't long before the real estate around Little Flower became a hot commodity. Development in the Little Flower neighborhood between Tenth and Sixteenth Streets saw the introduction of mail service and the stringing of telephone lines, encouraging realtors, who intensified their efforts marketing land throughout the parish. About one hundred homes were being built in the area by forty-six different real estate firms, including the Justus Company, which had been building homes since 1910 and over the years erected many of the residential and commercial buildings on the Eastside.

The Little Flower parish and neighborhood were thriving by the latter part of the 1920s, with regular Sunday and daily Masses, a solid school curriculum and initial ministries, but the stock market crash in 1929 and the resulting Depression caused church contributions to dwindle as parishioners lost their jobs, their homes and their life savings. Even Father Duffey struggled to meet the interest payments on the church building, and he was forced to borrow money to make ends meet.

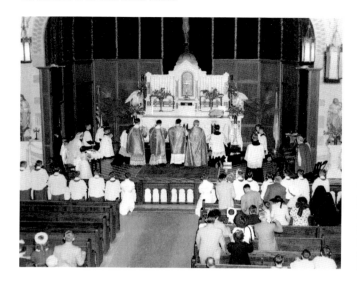

The original Little Flower Church, which now serves as the gymnasium for the school. *Courtesy of the Little Flower Catholic Church.*

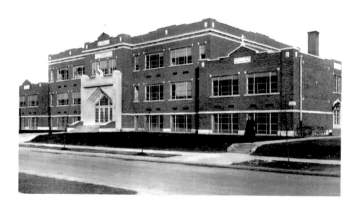

Saint Therese of the Little Flower Catholic Church as it looked in the 1920s before other buildings graced the campus. *Courtesy of the Little Flower Catholic Church.*

Justus Homes has been building both residential and commercial buildings throughout Indianapolis since 1910. *Courtesy of the Justus Company.*

Throughout the Depression, Little Flower maintained a "can do" attitude, and the various clubs and associations organized every kind of fundraiser to keep the parishioners' spirits up during the difficult time. From bake sales and bridge games to variety and hobby shows, every effort was made to keep the Little Flower community together.

"It was surprising to me how the ladies could bake goodies in spite of the rationing," said parishioner Alma Hoffman.

It may seem hard to believe, but the parish actually grew during the troublesome '30s. About five hundred families were registered in the parish, and three hundred children were being educated in the school, which had to expand its classrooms to seven from the initial four. Little Flower celebrated its first championship football team in 1932, and the Men's Club was able to secure enough funds to purchase a car for Father Duffey and redecorate the church. By the close of the decade, Father Duffey had died, succumbing to a short illness. Father Jerome Pfau arrived to assume the pastoral duties.

Father Pfau only served as pastor for two and a half years, but he was able to make significant contributions to the parish, including the establishment of a future building fund. When he became ill, he was relieved of his duties. Father John Riedinger came to Little Flower, serving as pastor during the World War II era. Father Riedinger was horrified to learn that he had inherited a staggering debt of $126,000 and immediately launched a campaign to eliminate the mortgage on the building by instituting cost-cutting measures during the 1940s.

"Community" Growth

During the late 1930s and early '40s, the Eastside of Indianapolis and what is today known as Warren Township were still farmland, with a few scattered businesses here and there. The Near Eastside remained a destination for people who wanted to be able to catch a movie for a dime at the Rivoli or Irving Theatres or grab a bite to eat at the Northway (later the Steer-In) or Emerten Restaurant.

In the 1940s, the *East Side Herald* told the stories of the people and the places that dotted the Eastside of Indianapolis. Originally housed at 225 North New Jersey Street in the Printcraft Building, the paper moved to Washington Street after the war and eventually to Michigan Street, where it remained until 2005 before moving to the Irvington area. For seventy-three years, the *East Side Herald* was the voice of the people, telling their stories, reporting places in the community and remaining a beloved periodical

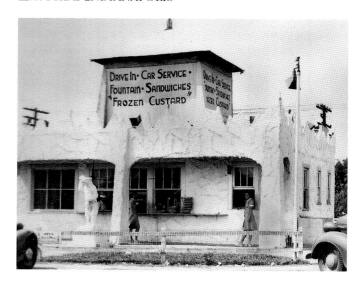

The Northway Restaurant was known for its polar bear entrance. Today, the location has had a facelift and is known as the Historic Steer-In. *Courtesy of Casey Kherer.*

for Eastside residents. In fact, the 2008 anniversary edition of the paper showcased a number of businesses on the Eastside that had been long-term advertisers with the paper throughout the Depression and war years and remain a part of the Eastside community to this day, including Moore & Kirk Funeral Home, Deering Cleaners, Marsh Supermarkets and Standard Grocery Store.

"Workers could find good jobs at the Western Electric Plant, Ford, RCA and many other places on the east side," reported the *East Side Herald*. "Houses were built and neighborhoods grew…drive down any street on the east side and you'll see the past."

It was a time of patriotism, and according to the Little Flower's published history, at least three hundred men and women of the parish and its neighborhood enlisted in the armed forces, serving in both the Pacific and European theatres. During the days of rationing and sacrifice, war stamps were often given as prizes at card parties, and war bonds were raffled off. Parishioners were also encouraged to donate blood to the Red Cross and to do all that they could for the war effort while also working to eliminate the parish debt.

The Little Flower community's diligence succeeded, and by January 1946, the gigantic debt was paid off and celebrated with a solemn high Mass and a public mortgage burning. Still, despite this triumph, the need for funds was great. The sisters of Saint Francis, who had dedicated their service to educate young minds throughout the Eastside, were still housed on the upper floor of the Little Flower Church building. Not only had their numbers doubled in

EAST SIDE HERALD – 73 YEARS OF SERVING THE EAST SIDE

The *East Side Herald* was a weekly source of news for the Eastside community. The paper shut its doors in early 2009. *Courtesy of the* Herald Weekly.

recent years, making the quarters less than desirable, but also a good night's sleep was hard to come by when many meetings, dances and other events were held in the same building. A proper convent was a must. A donation of ten dollars by a group of third graders started the building fund, and thanks to the generosity of parishioners, the new home for the sisters was completed in 1947. Today, the former convent serves as the parish offices.

By the late 1940s, the parish numbered 2,700, with 512 children enrolled in the school. The postwar era gave Americans more discretionary income than they previously had, and this, combined with federal home loan assistance, gave families an opportunity for home ownership. Any available land that was near the Little Flower area was quickly bought and developed, enabling the returning GIs and their families to establish homes in the neighborhood.

According to the parish history, various members of the Little Flower community were also instrumental in the founding of the Community Hospital at Sixteenth Street and Ritter Avenue. This medical facility, opening in 1956, was born from another grass-roots effort that saw organizers collect donations door to door and set up payroll deductions, providing a public

Community Hospital East began as a grass-roots movement to offer large-scale medical services to those on the Eastside. *Courtesy of Community Health Network.*

portion of the millions it would take to establish the Eastside hospital. Its groundbreaking in 1954 was attended by Vice President Richard Nixon, and today residents throughout the Eastside take pride in knowing that this is the hospital they helped create. From the ladies in nearby Irvington who helped establish the auxiliary to the neighborhood doctors who helped staff the hospital, from the outset everyone enjoyed knowing that the Community Hospital was truly a community effort. Today, the Community Health Network is one of the largest not-for-profit entities in the Indianapolis area, employing 3,078 people at the Eastside location.

"I don't think you can underestimate the importance of Community Hospital in the neighborhood," said Jim McGuinness, vice-president for Institutional Advancement at Scecina Memorial High School and a longtime Eastside resident.

> *The three things that have held this neighborhood together all these years have been Little Flower, Community Hospital and Scecina. Prior to the last couple of years, if you looked at the professions people have gone into over the years, the number one profession is nursing. That's not a coincidence.*

Scecina Memorial High School

Though Little Flower was an important component of the Eastside Catholic population, it was far from being the only Catholic entity serving the residents

of the Eastside. Holy Cross, Saint Philip Neri, Our Lady of Lourdes, Holy Spirit, Saint Bernadette and Saint Simon were among the parishes meeting the spiritual and educational needs of those in the East Deanery.

It seemed only natural that a Catholic high school would be constructed in the area in order to offer a Catholic-based secondary education for families. In February 1952, Archbishop Paul C. Schulte initiated a diocese-wide fund drive to help establish the new inter-parochial high school. Father Harry Hoover was slated to serve as the first principal of the new institution, and a tract of land was secured on the 5000 block of Nowland Avenue, just a few blocks from Little Flower. The $1 million initiative was designed by architect Charles Brown and built by the F.A. Wilhelm Company. Father Hoover was living at nearby Little Flower, serving as an associate while overseeing the unnamed high school project. As the building was under construction, in November 1952, the chancery office announced that the new facility would be named in honor of Father Thomas Scecina, the only Indianapolis archdiocesan priest to perish in World War II.

Father Scecina, the third son of George and Mary Anna Scecina, was born on September 16, 1910. He grew up in Linton, Indiana, and attended Saint Peter's Elementary School before entering Saint Meinrad Seminary. After completing his seminary education, he was ordained on June 11, 1935. His early career included stints at Holy Trinity Church and Saint John's Church before enlisting in the Chaplain's Reserve Corps on October 5, 1939. Father Scecina was stationed with the Fifty-seventh Infantry Division at Fort McKinley on Luzon in the Philippine Islands. He ministered not only

Father Thomas Scecina and his family before his death in World War II on the Arisan Maru. Father Tom is on far right side. *Courtesy of Scecina Memorial High School.*

Scecina's class of 1957. This was the first group of students to experience the new interparochial high school. *Courtesy of Scecina Memorial High School.*

to the American GIs but also to the Filipinos who were living nearby until the islands fell into the hands of the Japanese in 1942. He was taken prisoner and participated in the infamous Bataan Death March, during which he continued to provide spiritual support for the men of his regiment.

Two years later, Father Scecina boarded one of the ships designated to move POWs from the Philippines to Japan in order for them to work as slave labor. Aboard the *Arisan Maru*, Father Scecina endured two weeks of torture before the ship was torpedoed by an American submarine. As the Japanese abandoned the vessel and with many men unable to swim, Father Scecina remained on the ship, hearing confessions, praying with the men and comforting them while the ship went under. Posthumously, Father Scecina received the Purple Heart, the Silver Star and the Bronze Star for his heroism.

Given the era, it was appropriate to have the school named for the fallen chaplain. He may not have been the most well-known priest, but his reputation of sacrifice in going above and beyond what was required was

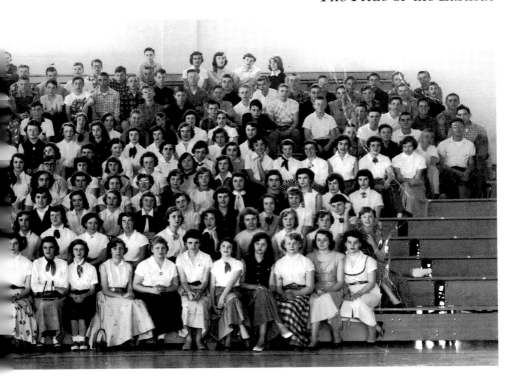

something many people could understand and aspire to. To this day, the unofficial school motto is "Give that little extra."

By the end of the year, the archdiocese had accumulated the $1 million it sought to build the school, and a cornerstone ceremony was conducted by Archbishop Schulte on December 21, 1952. More staff positions were appointed throughout the first half of 1953, and on May 15, registration for the first academic year was held at Little Flower Grade School.

The plan for the infant high school was to begin with a freshman class and add additional grades in the following years until all four high school classes were accommodated. According to accounts, the spots quickly filled, and in September, classes commenced with 128 freshman girls and 127 freshman boys. Instructors included three priests and several Franciscan sisters who lived at the Little Flower convent.

Despite some initial setbacks, the students were eager to be the charter pupils of the new school and took their roles very seriously. One young lady in the inaugural class said she remembered walking into the new building for the first time after having to navigate her way on wooden walkways, as the construction of the building had left muddy terrain all around the property.

The finished building of Scecina Memorial High School located at 5000 Nowland Avenue. *Courtesy of Scecina Memorial High School.*

One of the challenges of the early years was the name of the school. Many believed the moniker was unpronounceable, and most assumed that the school would come to be known as Memorial High School rather than Scecina. In fact, the school emblem is a large block letter *M*, which is directly related to the early attempt to shorten the school's name. There was really no need, as the name Scecina was readily embraced by the public.

A New Church

With Scecina now part of the landscape, Little Flower was also experiencing its own set of growing pains. Father John Riedinger saw the need for a permanent church and asked the parishioners to begin budgeting three dollars above their current tithe to help create the new structure. Fundraising for the new church began in 1954, but by 1957, just as Scecina was graduating its first class, much of the money that had been saved went toward new classrooms, which were ready by the fall of that year. Unfortunately, in 1958, Riedinger fell ill and was hospitalized for a period of time. Still, by 1960, the goal of $350,000 for the new building had been met. Now back on his feet, Father Riedinger pleaded with the parishioners to come up with an additional $100,000 in order to outfit the new church. With the money raised, Archbishop Schulte agreed that construction could commence.

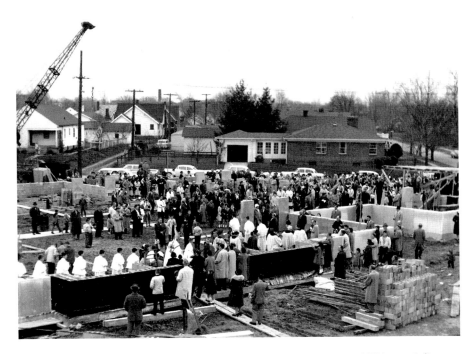

The blessing of the new Little Flower Catholic Church on the corner of Thirteenth Street and Bosart Avenue. *Courtesy of the Little Flower Catholic Church.*

According to the published parish history, Father Riedinger was responsible for the design of the church—everything from the granite altars, which were inspired by Leonardo da Vinci's *Last Supper*, to the stained-glass windows that grace the exterior of the building depicting some of the most well-known stories of the Bible. The new church's dominant feature was the "Rose Window," which was donated by Mr. and Mrs. Arnold Cook, who not only provided the funds for the window but also organized the dedication of the new church. By this time, Little Flower boasted more than five thousand members and was the largest parish in the city.

Not long after the new church was dedicated, Father Riedinger's health began to fail. He turned to his associates, who took over many of his duties, but after twenty-four years of service to the parish, Father Riedinger retired and Father Raymond T. Bosler became pastor. It was a time of great change within the Catholic Church. Not only was Father Bosler appointed a monsignor within a short period of time, but also the entire Catholic community on the Eastside of Indianapolis and throughout the world became caught up in the wave of changes that resulted from the Second

Vatican Council (of which Monsignor Bosler was a part), and the church made a sincere effort to be more open to the needs of modern society.

"When Monsignor Bosler became our pastor, it opened a new world for all of us," said Betty Murphy in the eightieth-anniversary history of Little Flower. "He just returned from Vatican II and there were so many wonderful changes. Women could help at Mass and have a voice in the church."

Changing Times

During the late 1960s, the Eastside continued to change along with the rest of the country. As Senator Robert Kennedy began his campaign in Indiana to become the Democratic presidential candidate in 1968, not only did Scecina's band play at Kennedy's arrival in Indianapolis, but also his wife, Ethel, spoke at the high school. Senator Kennedy spent a day traveling along Tenth Street, rallying support for his campaign, and rumors persist that the Kennedys patronized McShane's Lounge at Emerson Avenue and Michigan Street, but no one knows for sure if this local legend has any truth to it.

At Little Flower, Mass was now being said in English, as mandated by the Vatican II documents, and the priest no longer faced away from the congregation. Rather, by standing behind the altar and facing the worshippers, congregants were actively engaged in the Eucharistic celebration. By the early '70s, more changes were in store as the baptismal room became the Blessed Sacrament Chapel, the altar was moved to its current location in the center of the church and the choir moved from the choir loft at the back of the church to the former sanctuary, now behind the altar and facing the congregation as well.

A crisis at the archdiocese in the early '70s caused some concern among the deaneries. According to David Smock's thesis on the history of Scecina High School:

> The Indianapolis High School Fund had produced enough money for brick and mortar, but then they realized that the parishes could not support their own parish operations, their grade schools, and contribute to the high school.

It seemed that every other year there was a rumor that Scecina might close. According to Jim McGuinness, part of the problem came from the opening of the new public John Marshall High School on the Far Eastside, which caused a significant number of students to leave the school.

Ethel Kennedy, wife of Senator Robert Kennedy, makes a visit to Scecina Memorial High School during the 1968 political season. *Courtesy of the* Scecinarama.

"Parents were getting scared," McGuinness said. "Western Electric was thinking about closing and people were getting laid off. It was free over there to send their children to Marshall, and that's what started the decline in enrollment, but we eventually leveled off."

Judy Nichols, a Little Flower graduate, former Scecina student and faculty member, said it was tough to keep spirits up during those days. "We often thought it would be our last year and then we would have five or six good years and the rumors would start up again," she noted. "I resented the rumors, and I didn't want to believe them or spread them."

Nichols began teaching Spanish at Scecina in the 1960s. She was Miss Della-Penna then and was well liked by all of her students, especially one named George Henninger, who wanted her to meet his brother, John. After much cajoling, John Henninger met Della-Penna. A courtship and marriage soon followed.

"He also taught at Scecina and coached sports," she said. "He believed in Christian service and made a point of getting his classes to collect food and clothes for the needy. He was loved by his students, as well as the entire Scecina community."

In 1976, Henninger applied for the vacant principal position at Little Flower School and was hired in July. Sadly, in August he learned that he only had three months to live. While he was technically the principal of Little Flower, Sister Barbara Piller, of the order of Saint Francis, filled in the void, assuming many of his duties during that difficult time. On December 5, 1976, John Henninger died. Not only had Little Flower lost a principal, but Scecina also lost a friend. Smock's thesis recalled that Henninger was a man who enjoyed life, but he lived his life "being mindful of the needs of others." To help honor the memory of a man who had embodied Christian service, in 1977 Scecina began bestowing the John Henninger Memorial Award for Christian Service to a senior who exemplifies the qualities that Henninger possessed.

Eventually, enrollment stabilized, and the parochial schools were able to remain open, continuing to minister to and educate students of all backgrounds on the Eastside. Throughout the 1980s and '90s, both Little Flower and Scecina contributed to the stability and prosperity of the Eastside neighborhood. When Monsignor Bosler stepped down from his pastoral duties at Little Flower, Father Fredrick Schmitt arrived to assume the helm. The church saw an addition of new members when Saint Francis de Sales closed in 1983, and two years later the parish was thrilled to welcome Father Robert Borchertmeyer, a popular associate pastor from 1958 to 1968 who returned to serve as pastor.

It was not uncommon for those who graduated from either school to put down roots in the neighborhood and allow their children to follow in their footsteps. Parents enjoyed the roles that both institutions played in shaping their children through Christian retreats, service projects, academics and athletics.

"For me, staying in the neighborhood was never a question," recalled Nichols. "I couldn't imagine my children growing up anywhere but on the Eastside and attending Little Flower and Scecina."

The unexpected death in 1995 of "Father Bob" Borchertmeyer in a car accident was another painful blow to the community, which had recently mourned the death of former Scecina principal Larry Neidlinger. After a transition filled with sorrow, the parish faced some bitter economic truths. Budgets were slashed. Appeals were made in order to dig the parish out of debt and to begin making fundamental improvements to the property and buildings that have continued to the present time. For a while, Scecina considered moving to a former public school building at Post Road and Tenth Street, but ultimately the Scecina board decided to keep the school at its current campus. The early years of the twenty-first century saw both

Little Flower Catholic Church as it stands today. Both Little Flower and Scecina have served as anchors in the neighborhood for many years. *Courtesy of the Little Flower Catholic Church.*

schools enjoying visual and internal upgrades thanks to the generous support of the archdiocese, private donations and the community. McGuinness noted that the generosity of the area cannot be overstated. "I know that Scecina is not moving," he said. "Over the past few years, the archdiocese has made significant financial commitments to the school, and I think we will stay right here on the Eastside and keep moving forward."

Current pastor for Little Flower Father Robert Gilday said that both schools have continued to thrive because, at their cores, both Little Flower and Scecina are neighborhood institutions.

"I have never been in a parish where the entire parish is supportive of the school and not just the parents of the students or former students," he said. "We often say that Little Flower and Scecina are anchors for the neighborhood, but the strong neighborhood also bolstered both schools."

WHERE THE OWLS
SAY "WHOM"

Irvington, the cultural and academic cornerstone of the Eastside, was designed and planned during a period of time that Mark Twain called the Gilded Age. The concept was to create a community that would be a residential suburb of a larger city while still maintaining its own identity. This is what Sylvester Johnson and Jacob Julian had in mind when they left eastern Indiana to create Irvington five miles east of Indianapolis, along the National Road (today's Washington Street or U.S. 40).

The original 1870 plat of Irvington was on a 320-acre tenant farm that the duo purchased for $100 an acre. Not only did the new community have the advantage of being situated along the National Road, but two railroad lines also offered plenty of accessibility to and from the suburb. Johnson and Julian set out to create a utopia with winding, curvilinear streets. They also made provisions in their plans for a public park and, hopefully, a local college.

It was Julian who gave the name Irvington to the new community after his daughter suggested that he name the town for his favorite writer, Washington Irving. As time moved on, it was not only the town that was named for a celebrated writer—the streets also bore literary names, such as Emerson Avenue, Hawthorne Lane and Whittier Place. Johnson eschewed naming rights in favor of a provision in the deeds that prohibited alcohol sales within the town limits. (This provision is still in place and is examined whenever a new business moves into the Irvington area.)

Like Woodruff Place, Irvington had some initial setbacks during the Panic of 1873, and not long after he helped create the town, Jacob Julian left the community when he was nearly forced into bankruptcy. Still, slowly but surely the town began to grow as the Victorians fell in love with the park-like lots and various retail commercial ventures taking root around the railroad station. Within a few years of its founding, Irvington was able to turn its dream of having a college into a reality when North Western Christian University needed a new home.

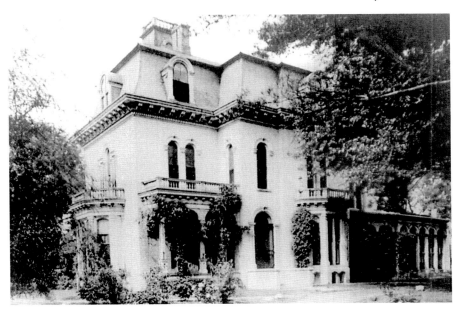

Jacob Julian's home was located across the street from Sylvester Johnson's. It shows the unique architectural heritage of Irvington. *Courtesy of Larry Muncie.*

Bringing in Butler

Though there are few physical traces of the Irvington campus remaining today, the legacy of Butler University is still a part of the area. A memorial stone stands at the corner of University and Butler Avenues to commemorate Butler's years in Irvington from 1875 to 1928. The Bona Thompson Memorial Center, Butler's library, is the only remaining building from the Irvington Butler campus, but throughout the neighborhood several homes remain as a tribute to the faculty and students who made Irvington the hub of academia and spawned the notion that in this atmosphere of culture, "in Irvington, even the owls say 'whom.'"

In 1873, North Western Christian University hoped to expand from its home on College Avenue and Thirteenth Street in downtown Indianapolis. Columbus, Indiana, was considered, but Irvington, which had hoped to provide a local college to area residents, jumped at this perfect opportunity to secure the school and immediately offered twenty-five acres of land and the initial $150,000 to make the dream a reality.

Within a year, the sounds of construction could be heard all over town as the new building began to take shape on the Irvington landscape. When

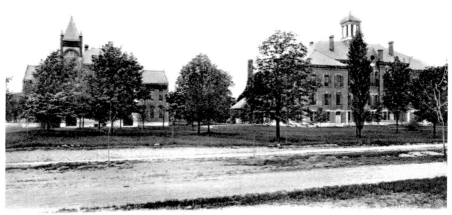

Butler University, Indianapolis, Ind.

The Butler main building and Burgess Hall were the predominant structures on Butler's Irvington campus. *Courtesy of Don and Lisa Flick.*

classes commenced in 1875, the university began to create a cultural atmosphere that would eventually lead to enrichment opportunities such as plays and lectures that were extended not only to the university community and Irvington but to all of Indianapolis as well. In 1877, the university's name was changed to honor Indianapolis attorney Ovid Butler, who was instrumental in the founding of the school.

The main building cost $15,000 to erect and attracted students, who arrived by rail, trolley or on foot to attend classes. This edifice had within its walls a chapel, a library and classrooms that also served as meeting spaces. Because the college was affiliated with the Disciples of Christ, many of the professors also acted as ministers in the community. In fact, until some of the local churches were built, the main building was the site of Sunday services as well.

In the following years, other structures began to fill the Butler campus. In 1890, Burgess Hall, the science building, was built. It was named for Otis Burgess, who was Butler's president from 1873 to 1881. He was instrumental in equalizing the curriculum for both male and female students. Land for the Butler athletic field was purchased in 1905 by William Irwin. It included a quarter-mile track, a football field and spectator stands, and for the time period, Butler's Irwin Field was one of the best athletic fields in the state. When the "Butler Eleven" football team played, as many as ten thousand fans might come out for a game. Coach Evans Woolen, a Yale graduate, was instrumental in pulling the team together and giving it an edge over its rivals.

While young coeds pose for a photo outside of Butler's main building, Sigma Chi fraternity members admire the view. *Courtesy of Howard Caldwell Jr.*

There was also a women's dormitory on the Irvington campus, as well as a "summer house" near the tennis courts that students used when they wanted to watch an athletic match under shelter. The last building to grace Butler's Irvington Campus was the Bona Thompson Memorial Library, which was built in 1903 from designs created by architect Jesse Johnson, who went on to design Arlington National Cemetery. Mr. and Mrs. Edward E. Thompson donated the land across from their home at Downey and University Avenues, along with $40,000, to have the library built in honor of their daughter, Bona, who was an 1897 Butler graduate. The young coed died following her return from a European trip with her mother during which she had contracted typhoid fever. The library was not only used by Butler's students and faculty but also by the whole Irvington community, making it the first public library in the town.

Butler's educators were a distinguished group of people who were truly loved and admired by the community. Alan R. Benton, one of the university's first faculty members and its president during the Civil War years, resided in a home on Downey Avenue during his second term as university president. The Second Empire–style home, built by Nicholas Ohmer, is today known as the Benton House and serves as a gathering place for music recitals, as well as a venue for private parties and community events. It is on the National Register of Historic Places and is a museum house complete with period furnishings.

Another Butler president who was well known in the Irvington community was Thomas Carr Howe. Not only did Howe head a distinguished panel of educators, but he also served as the first president of the Irvington Ice and Coal Company. Completed in 1915 on South Ritter Avenue, the company provided neighborhood residents and businesses with ice and coal deliveries until the days of electric refrigeration. Today, Thomas Carr Howe Academy, a public school, bears the name of this respected educator and civic leader.

Throughout Butler's presence in Irvington, many of the community's homes often served as chapter houses for fraternities and sororities and as faculty residences. Many current homeowners delight in learning of their homes' Butler connection. Whether the homes are near the hub of the former campus; on Downey Avenue, where they can be seen from the steps of the Bona Thompson Memorial Center; or dot the various outlying areas, such as along Audubon Road and Pleasant Run Parkway, those who reside in them know that they represent a very special part of Butler's past.

The College of Missions, operated by the Christian Woman's Board of Missions, was not part of the Butler campus, but the two institutions formed such a symbiotic relationship that many considered the college to be part of the Butler campus. The concept of the college was to educate and train Disciples of Christ missionaries for their work within the United States and on overseas assignments that included missions in Jamaica, India, Mexico, the Congo and the Philippines, among others.

From 1910 to 1927, the College of Missions graduated about 309 students, who took part in the annual Ivy Ring Ceremony on the Missions Building grounds. Ivy was taken from the building and was used during graduation exercises to create a symbolic ring to demonstrate the connection that the missionaries had to one another and to the college. In 1928, when Butler moved to the Northside of Indianapolis, the College of Missions moved to Hartford, Connecticut.

It was as though the good times were not meant to last with Butler as a part of the Irvington area. Though the school was well received, and plenty of Irvington residents pledged financial resources to keep it there, the frequent roar from the two railroad lines made studying a bit of a challenge, and eventually more room was needed for the growing university. Butler relocated to the Northside of Indianapolis, where it remains to this day, and many of the Irvington residents who supported the school in its early days continue to make Butler their higher education choice.

"It was difficult for Irvington to lose Butler," said Irvington historian Steve Barnett.

Thankfully, the community didn't lose its cultured reputation because the former College of Missions became the new headquarters of the United Christian Missionary Society, which brought learned people into the community. The society's administrators and the missionaries who returned to the headquarters on home leave stimulated Irvington with a continued appreciation of the arts and an interest in public affairs. The ambiance of the "Classic Suburb" remained.

Most of the university buildings that were once part of the Butler campus fell into disrepair and were vandalized before being systematically demolished in the late 1930s. Today, many of the street names still reflect Butler University's time in the area, and during the school's sesquicentennial, a class was offered to give students insight into the roots of the university that was once a major part of this Eastside community.

Beyond the Butler Days

While Irvington took great pride in having an institution of higher education in Butler University, the community also had a number of private and public schools for its young learners. Early Irvington students attended the Mount Zion School at Arlington Avenue and Pleasant Run Creek. The one-room subscription school was hardly adequate for the children, and in 1874, the first Irvington public school was built at the southeast corner of Audubon Road and University Avenue, across from Irving Circle. With 330 students and 8 teachers, the school was a thriving institution until it burned down on December 16, 1898.

The second Irvington school was built just south of the original site, but that building, too, burned down in January 1903. Since Irvington had been annexed to Indianapolis the preceding year, the city school system was responsible for building a new facility. The Irvington School, built at Washington Street and Ritter Avenue, across from the new firehouse, was ready for students in the fall of 1903. The school's name was changed to George Washington Julian School No. 57 to honor a former Civil War–era congressman and champion of civil rights who later lived in Irvington. As Irvington grew, the school building quickly became crowded, and there was a need for additional facilities.

Over the years, new public schools were built to serve Irvington's children—Ralph Waldo Emerson School No. 58, Anna Pearl Hamilton School No. 77 and George B. Loomis School No. 85. Our Lady of Lourdes

Like the first Irvington School, the second institution was also destroyed by fire. The third public school, No. 57, still stands today. *Courtesy of Larry Muncie.*

School was opened in 1911 to meet the needs of Irvington's Catholic students. Even with these new elementary school buildings, overcrowding continued, and it was not uncommon to see portable classrooms dotting the perimeters of the facilities, accommodating the overflow while awaiting building additions. Today, Our Lady of Lourdes School, School No. 57 and School No. 58 continue to provide quality elementary educational opportunities for area children. Within the last decade, the Irvington Charter School, a new elementary school, was built, and the Irvington Charter High School relocated to the former School No. 77 site.

The Christian Park School No. 82 was built in 1931 to serve students in south Irvington and neighborhoods to the west. The original building, located on a donated tract of seventy-five acres from the estate of Dr. Wilmer Christian and his wife, Edna, featured thirteen classrooms, practical arts facilities, a gymnasium and a children's activity room. The playground was designed to accommodate ice-skating in the winter, while all of the classrooms were wired for radio so that daily broadcasts could be conducted within the building. The new building replaced a number of portable classrooms that had been in use for a number of years.

A float from a Christian Park School No. 82 parade featuring a typical little red schoolhouse, complete with a bell. *Courtesy of Ron Huggler.*

The 1953 eighth-grade class of Christian Park School No. 82. Their principal was Jeanne Goss. *Courtesy of Ron Huggler.*

Abram Crum Shortridge was a superintendent of public schools and a president at Purdue University and helped establish the first public library in the city. *Courtesy of the Shortridge family.*

During the years in which Irvington was a town, Butler University provided a preparatory school for high school students. This was discontinued after the community was annexed, and area teenagers had to make the long trek to Tech or Shortridge High Schools.

Shortridge High School was named for Irvingtonian Abram Crum Shortridge, who was not only a champion of education in Indiana but also organized a committee of citizens to purchase books and establish the city's first free public library on April 9, 1873. He also served as the second president of Purdue University in 1874.

Shortridge and Tech were closer to downtown, and it was inconvenient for Irvington students to make the trek, so in 1938 the Indianapolis public school system constructed an Irvington high school named for Thomas Carr Howe, one-time president of Butler University. After years of campaigning for a high school, the building was a wonderful addition to the Irvington community and remained open until 1995, when the Indianapolis Public School (IPS) system made the decision to close it. Five years later, the building reopened as an IPS Academy.

Architectural Masterpieces

Like Woodruff Place, Irvington is known for its architecture. If you ask long-term residents what drew them to the community, they will most likely say that the historic architectural character of the area played a part in their decision. Many Irvingtonians have researched their homes only to discover that the structures were built by some of Irvington's most notable names or that the original owners were pillars of the community. Irvington's architectural styles range from designs of the late 1800s to those of the 1950s. Whether a homeowner is looking for the fine detailing of the Romantic period, a Queen Anne–style cottage or an Arts and Crafts bungalow, there is something for every taste in the area.

One of Irvington's grand homes, which still stands along South Audubon Road, is the George W. Julian Home. Julian was a former member of Congress and an abolitionist who was a brother of the town's founder, Jacob Julian. The Italianate-style home continued to be occupied after George W. Julian's death by his daughter, Grace Julian Clarke, a women's rights activist. After Grace Julian Clarke's death, and over the ensuing years, the house served as a boarding home and a sanitarium. Today, the home has been restored and is once again a private residence.

Another house that is not hard to miss is the Eudorus Johnson Home at the southwest corner of South Audubon Road and University Avenue, across from Irving Circle. This home features round turrets and Victorian Gothic architecture. The house was built in 1876 and was located across the street from the first Irvington school. The high gables and the steeple roof make this home impressive to look at. "Dora" Johnson was the son of the

This Queen Anne–style home is one of many architectural designs found in the Irvington community. *Courtesy of Robert Montgomery.*

The Eudorous Johnson House on Audubon Circle is known for its Gothic architecture and commanding presence. *Courtesy of the Irvington Historical Society.*

other town founder, Sylvester Johnson, and he served as deputy auditor and deputy treasurer of Marion County. In the 1890s, he also held the post of city controller. After his years of public service, he remained in the banking sector until he died in 1908.

Driving along Emerson Avenue at New York Street, one can easily see a row of steps leading to a bramble- and brush-filled property, with only a hint of a home behind. On top of that hill is the former home of Irvington's Frank McKinney "Kin" Hubbard, the creator of Abe Martin, the rustic philosopher of Hoosier homespun wisdom. The comic character appeared in the *Indianapolis News* from 1904 to 1930 and was syndicated in over three hundred other newspapers. The home overlooks Pleasant Run Parkway and was designed in 1909 by architect Frank Hunter. The green space across from the home is the Kin Hubbard Memorial, a site dedicated to the memory of an Irvingtonian who, like his friend Will Rogers, is known for his wit and humor.

Thomas Carr Howe may be best known as the namesake of T.C. Howe Academy, but the man who served as president of the Irvington Ice and Coal Company and as president of Butler University lived in a home that, today, most associate with the Irvington United Methodist Church. At 30 North

Audubon Circle, the stately Tudor Revival–style home was built by Jacob D. Forrest in 1906. Howe bought the home in 1914, when he was president of Butler, and lived there until he sold the property to the Methodist Church in 1924.

Not only are the homes in Irvington architectural masterpieces, but the religious community has also provided tremendous style and design to the neighborhood as well. From the earliest congregation, Downey Avenue Christian Church, and the Irvington United Methodist Church, which incorporated the former Howe home into its large building, to the Irvington Presbyterian Church's Tudor Gothic–inspired edifice, the church communities of Irvington take their houses of God seriously and give them the same painstaking detail that is evident in any Irvington building.

Of course, some of the structures in the neighborhood are not remembered for the people who built them, nor for their architectural styles; rather, they are remembered for the dark events that took place there.

A Serial Killer in the Community

In October 1894, a handsome but abrupt gentleman who called himself Dr. A.E. Cook arrived in Irvington. He was traveling with an eight-year-old boy and was looking to rent a home for his widowed sister. Dr. Cook found a secluded property on Julian Avenue that he deemed satisfactory and immediately outfitted the home with a large, commercial-grade wood stove. No one in the community knew that on this quiet residential street resided America's first serial killer: Dr. H.H. Holmes.

Holmes, born Herman Mudgett, gained notoriety as the mastermind behind the "Murder Castle" in Chicago, a hotel that was later found to be equipped with trapdoors, sealed rooms into which gas could be infused and a crematorium in the basement. The building itself did not have an uncommon appearance, as many large hotels were being constructed at that time in order to accommodate the twenty-eight million tourists expected to descend on Chicago for the 1893 World's Columbian Exhibition, but no building was as deadly. Holmes was to become infamous for luring young women to his hotel with his charm and the promise of a job in the big city, only to have his conquests disappear without a trace. By the time authorities caught on to what Holmes was doing in Chicago, he was long gone. The only evidence of his crimes was the castle's secret chambers, the few human bones found in an acid vat and the approximately two hundred missing person reports that led to the door of Holmes's "World's Fair Hotel."

The event that brought Holmes to Irvington was less grand in nature but just as toxic. Holmes concocted an insurance fraud scheme with his business partner, Benjamin Pitezel. The plan was to fake Pitezel's death and split the proceeds from the insurance policy. Holmes promised Pitezel that the corpse would be so convincing that even his own children would be able to identify him. A $10,000 life insurance policy was then obtained from the Chicago office of the Fidelity Mutual Life Association of Philadelphia, and the two men left the Windy City. They soon arrived in Philadelphia, where the fraud was to perpetrated.

Holmes ultimately killed Pitezel, making the death appear accidental. The insurance company paid off the policy, and then Holmes accompanied Pitezel's grieving family to their home in Saint Louis, where he explained the fraud scheme to Mrs. Pitezel and persuaded her to allow him to take the children to see their father, who he claimed was in hiding. Holmes then began an odyssey with three of the five Pitezel children, traveling throughout the northeastern United States and into Canada. By the time Holmes reached Irvington, eleven-year-old Nellie and fifteen-year-old Alice Pitezel had already disappeared. Only eight-year-old Howard Pitezel remained with Holmes when he arrived at the rented Julian Avenue cottage. Sometime around October 8, 1894, Holmes killed young Pitezel and placed his body inside the stove for incineration.

"Holmes was drawn to the area because it was a sleepy little out-of-the-way place where he could carry on his unspeakable crime unnoticed," said Irvington historian Steve Barnett.

Holmes then fled to New England, where authorities, pursuing him for insurance fraud and unaware of the murders, finally caught up with the madman and extradited him to Philadelphia for trial. In June 1895, the police began to unravel the whole mystery behind H.H. Holmes, the Murder Castle and the death of Benjamin Pitezel. Detective Frank Geyer tracked Holmes's footsteps, eventually finding the remains of Nellie and Alice Pitezel in Toronto, Canada, and settling on the Indianapolis area as the final resting place of Howard. On the last day that Geyer had allotted for his search, clues led him to Irvington (still its own town at the time) and the rented cottage on Julian Avenue. Geyer searched the property, but finding little evidence, he returned to his hotel in downtown Indianapolis. Three Irvington boys, who had been watching the search, then entered the cottage, and while roaming through the basement, one of them reached into the furnace flue and found a baked lump that turned out to be Howard's stomach, liver and spleen. The boys then told a local doctor of their discovery, and the doctor alerted local authorities, Geyer and a reporter from the *Indianapolis News*. Further searches

of the property led to the discovery of teeth, bones and a toy that Howard was known to have owned as a memento of the Chicago World's Fair.

Though Holmes confessed to twenty-seven murders, the official death count will never be known. He remained unrepentant of his crimes, and his memoirs, in which he claimed to have been "born with the devil inside me," have served as evil inspiration for several subsequent mass murderers. Holmes was publicly hanged on May 7, 1896, and his body was buried in an unmarked grave and covered with cement. The original home that Holmes rented in Irvington became a haven for trickery and mayhem. It was ultimately demolished when the large lot on which it stood was subdivided. Today, another home in the same style as the original stands near the site and is privately owned.

Enter the Dragon

Holmes wouldn't be the last resident on the Eastside to have his story and property become legendary for a heinous crime. In 1923, the widow of William Henry Harrison Graham, former American consul to Winnipeg, Manitoba, Canada, sold her large Queen Anne–style home to the grand dragon of the Indiana Ku Klux Klan, David Curtis (D.C.) Stephenson. When Stephenson took possession of the house, he began a massive $25,000 renovation to have the home transformed into a replica of Kalnkrest, the Atlanta, Georgia headquarters of the KKK.

Stephenson, who was born on August 21, 1891, hailed from Texas and was a born con artist. He often spun stories about his family's wealth, even though, in actuality, his parents were sharecroppers who often traveled with the harvest. He also regaled listeners with his heroics during World War I, even though he never saw combat. His ability to charm and impress those around him enabled Stephenson to earn a decent living, but upon moving to Evansville in 1920, he turned his attention to politics and became active in the Klan. He saw both of these entities as a way to achieve the wealth and power he so desperately craved.

By all accounts, Stephenson was a perfect match for the Klan. He quickly rose through the ranks until he was not only in charge of recruiting members in the state of Indiana but was also in charge of twenty-two other states. Stephenson was such an effective recruiter during this time that it is estimated that 250,000 men in Indiana (about one-third of the state) were members of the Klan.

During his rise, Stephenson gained a lot of political clout by influencing elections, with Klan-backed candidates getting elected to offices at all levels

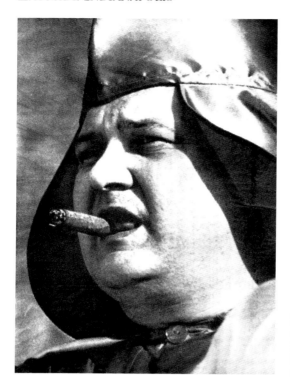

David Curtis (D.C.) Stephenson was the grand dragon and king kleagle for the Ku Klux Klan in Indiana. *Courtesy of Tiffany Photography Studios.*

of government—city, county, state and federal. It was his plan to have Indiana governor and Irvington neighbor "Big" Ed Jackson, who had won the 1924 Republican nomination and the subsequent election with Klan backing, to appoint him to U.S. senator Samuel Ralston's seat, which was expected to become vacant soon due to the senator's ill health. From this coveted office, Stephenson could then fix his eyes firmly on the White House, where his power would extend across the country.

"Stephenson liked Irvington because of its reputation as a community of culture and refinement, and he probably thought that living in Irvington would give him some social credibility," said Irvington historian Steve Barnett.

At the zenith of his power, Stephenson, known as "the Old Man" even though he was thirty-four years old, attended the inauguration party for Governor Ed Jackson in January 1925. It was at this event that he met Madge Oberholtzer, a twenty-nine-year-old statehouse worker who managed the Indiana Young People's Reading Circle. A former Butler University coed and Irvington neighbor of Stephenson, Oberholtzer saw him socially at subsequent parties, including events at his Irvington home. Although it was

Madge Oberholtzer was a Butler coed and statehouse worker who was brutally attacked by Stephenson. *Courtesy of Tiffany Photography Studios.*

rumored that Stephenson had a penchant for debauchery, womanizing and drinking, Oberholtzer was attracted to this handsome, powerful man who had expressed an interest in helping her with the reading program. Actually, Stephenson had conceived an idea to enrich himself by having Oberholtzer help him write a book on nutrition that would then be distributed to the schools in Indiana using her Reading Circle connections.

On Sunday afternoon, March 15, 1925, Stephenson called the Oberholtzer home looking for Madge, but she was out. When Oberholtzer returned home late that evening, she called Stephenson, and he told her that he was going to Chicago and needed her to come to his house so they could go over some changes in the proposed book. He said he would send one of

his bodyguards over to her home to escort her back to his house. When she arrived at his home, Stephenson was drunk. Despite her protests, he plied her with alcohol and ultimately abducted her, forcing her to board a train bound for Chicago. During the night trip north from Indianapolis, closeted in his private compartment, Stephenson cruelly assaulted Oberholtzer repeatedly.

By early morning, the train had reached Hammond, Indiana, and Stephenson made the decision to get off the train, just shy of the state line. He checked both himself and his captive into the Indiana Hotel under the names of Mr. and Mrs. W.B. Morgan of Franklin and had his henchmen check into the adjacent room.

Later that morning, ashamed and embarrassed by the attack and afraid that she wouldn't make it back to her Irvington home alive, Oberholtzer, under the ruse of wanting to buy a hat, visited a drugstore, where she purchased bichloride of mercury tablets, a disinfectant. She ingested the poison and it made her violently ill. Stephenson, faced with a potential disaster, ordered a car and, with his henchmen and Oberholtzer, began the trip back to his lair on the Eastside.

Unable to return Oberholtzer to her family in her ravaged condition, Stephenson and his cronies hid the young woman in a room above the carriage house behind his home while he concocted a plan. Oberholtzer, meanwhile, begged for medical attention. Stephenson eventually devised a ploy to return the girl to her parents while not implicating himself in her abduction. He instructed his guards to take Oberholtzer home and tell whoever was at the house that she had been in an automobile accident.

When Oberholtzer arrived at her house, her parents were downtown at a detective's office reporting their daughter's disappearance. Only a boarder at the home heard the concocted story as Oberholtzer was carried up the stairs to her room by Stephenson's henchmen.

Oberholtzer's parents returned home and found their daughter dying. They immediately contacted a doctor, who was unsuccessful in treating the girl. She clung to life for nearly a month after her ordeal before finally succumbing on April 14, 1925. During those last days, she was able to dictate a complete account of the crime. This deathbed statement set a legal precedent in American law and continues to be cited in law schools.

Stephenson, who had been arrested on April 2, along with his two bodyguards, on preliminary charges related to the crime, was rearrested on the day of Oberholtzer's burial, April 16, and charged with second-degree murder. The months leading up to the trial revealed details of the crime and of the Klan that were full of media fodder: sex, power, money and corruption.

The Old Man's trial, set in Noblesville, Indiana, because it was clear that he couldn't get a fair trial in Indianapolis, began on October 12 with jury

selection. Testimony revealed that Oberholtzer's wounds consisted not only of rape but also of bite marks on her body that looked as though she had been mauled by a cannibal. Oberholtzer's deathbed testimony was read in court, and the man who once proclaimed, "I'm the law in Indiana" was found guilty of the crime on November 14, 1925, and sent to prison in Michigan City, Indiana. The Old Man believed, however, that his political friends, particularly the governor, would spring him. He remained in prison.

Abandoned, Stephenson began giving prosecutors information about the pledges that elected officials had made to him in order to secure his support. The ensuing trials saw the mayor of Indianapolis go to prison, along with others. Governor Ed Jackson escaped prison on a technicality. The power of the Klan in Indiana was destroyed, and one was hard-pressed to find anyone who would admit that he had ever been a member. Stephenson remained in prison until 1950, when he was paroled. Unable to abide by the conditions of his parole, he was returned to prison until 1956, at which time he was paroled again. Stephenson's Irvington home was eventually sold to cover his mounting legal debts. He never offered any remorse for his actions and moved out of the state after his release. D.C. Stephenson died in Jonesboro, Tennessee, on June 26, 1966.

A Close-Knit Community

Irvington has always been a close-knit community, with thriving religious congregations, businesses and organizations that have supported the neighborhood in numerous ways. Downey Avenue Christian Church was the first religious congregation, established in 1875, followed by Irvington United Methodist Church, Irvington Presbyterian and, finally, Our Lady of Lourdes Catholic Church in 1909. After Butler left the area, the Irwin athletic field became a YMCA park, with programs for youth throughout the Irvington community. Hi Y clubs were also popular in various high schools and fostered a sense of service organizations for young people.

Greg Bierck wrote in the *Jennifer Letters* that when he was a boy, he remembered going to Buster Brown for shoes and getting groceries with his mother at Clapp's Market, or wherever the most trading stamps were being given away.

We could ride our bikes to Linder's Ice Cream store or the Dairy Queen for a dime cone or a twenty-five-cent sundae. Mom might take us out to dinner, especially if dad was on the road, to the Double L Drive-In, where there

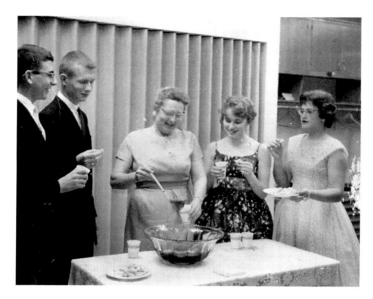

The Howe Hi Y Club was one of many on the Eastside that incorporated service with YMCA values. *Courtesy of the YMCA of Greater Indianapolis.*

Young children play box hockey at the YMCA park in Irvington that was once Butler's athletic field. *Courtesy of YMCA of Greater Indianapolis.*

were car hops and you ate in the car. The best root beer was at the Little Brown Jug, a bit farther up on Arlington Avenue.

Employment opportunities abounded for those in the Irvington community. One of the biggest was located on the seventy-five acres of farmland formerly belonging to the Shimer family that was purchased by the International

International Harvester was located on Brookville Road. The plant eventually became Navistar. *Courtesy of Steve Barnett.*

Harvester Company in 1937. The original land contained a thirteen-room brick home, which was built in 1873, along with a large barn, a golf driving range (used in the mid-1930s) and a race track for exercising horses. People could pay ten cents on Sundays to ride their bikes around the track.

The farmhouse served as the initial office building for International Harvester (IH), while the surrounding land was excavated for other operations. The groundbreaking for the new engine plant occurred on August 16, 1937, and on April 4, 1938, the first truck engine came off the assembly line. By the end of the year, more than eleven hundred employees were on the payroll. Among its many customers, International Harvester created engines for the Ford Motor Company and the U.S. military.

The foundry building was completed in 1939, and thanks to the effects of the Depression, at one time more than twenty-five thousand employment applications were on file, offering IH the chance to select the most qualified candidate for the job.

Eventually, International Harvester became known as Navistar, and the plant grew to 1.1 million square feet. *Indianapolis Star* reporter Bill McCleery said that his late grandfather was one of the first employees at the Eastside manufacturing firm, moving from southern Indiana in search of a solid job opportunity.

"Over the years my grandfather worked his way up to the level of a shop foreman," McCleery wrote in the *Star*. "In his late 30s he had to have his leg amputated after a plant accident in which he was struck by a forklift."

McCleery says that his father will be on hand as Navistar closes its Indianapolis facility on July 31, 2009, and moves its diesel engine production elsewhere. Chuck McCleery has worked at the plant since 1963, when he became an apprentice after graduating from Howe High School in the winter term.

"I grew up playing in the sandbox with small-scale replicas of IH trucks and tractors," McCleery wrote. "As a kid, I owned a blue-and-white die-cast

A worker at the International Harvester plant. *Courtesy of Tiffany Photography Studios.*

A vintage photo of the Irvington World War I drum corps. Throughout the twentieth century, Irvington always showed patriotism. *Courtesy of the Irvington Historical Society.*

metal Scout made by Ertle that my grandfather bought me. I think I still own a red die-cast IH tractor."

In addition, Irvington's location along the National Road made it a hub for entrepreneurial enterprises such as clothing stores, grocery stores, a print shop and the Irving Theatre, where folks could catch a nightly show and the kids could see the weekly matinee on Saturday. Many remember the days of World War II, when there was a one-cent tax imposed on moviegoers as part of the war effort. Ellenberger Park became the venue for sporting activities

Mrs. Ronald Schultzn receives her husband's personal effects after he died in World War II. *Courtesy of the Irvington Historical Society.*

and pageantry and today is one of the few parks to boast a neighborhood skating rink, along with rolling hills that act as a natural amphitheatre.

"Irvington was home…it was the world I knew," said Bierck.

> *It was a place with all the convenience of a bigger city yet remained small and was relatively safe. The Eastside was blessed with heavy manufacturing—International Harvester, Chrysler, Ford, Western Electric—where workers were taken care of from cradle to grave. One could walk or ride a bike to most places.*

Today, Irvington's community is as committed to the Eastside "town" as its forefathers were back in the late nineteenth century. Not only do residents contribute their time and talent to the neighborhood, but they are also staunch supporters of the modern businesses that choose to make Irvington their home. Irvington does not shy away from the past in order to keep up with the times; rather, it uses that history as a gauge to constantly embrace the future.

COUNTRY AND COMMUNITY PRIDE

W arren Pride" is easy to catch if you live on the Eastside. Created about the same time that Indianapolis was named the capital in 1820, the township grew at the same rate as the Circle City, and today the two entities enjoy a symbiotic relationship that is interconnected and autonomous.

Warren Township was named for Joseph Warren Jr., a hero of the American Revolution who has been recognized for his bravery in the names of fourteen counties throughout the United States. Though it is unclear exactly who the first settlers were in the area, it is clear that once the township was established, early pioneer settlements quickly followed.

One of those early residents was Henry W. Brady. Born in Philadelphia, Pennsylvania, on September 16, 1794, he enlisted in the military at the age of nineteen, serving as a member of the Twenty-seventh Regiment during the War of 1812. After the war ended, Brady settled in Zanesville, Ohio, making his living as a farmer. Eventually, he relocated to Indiana in 1820, living first in Johnson County and later migrating north to Marion County. He ultimately settled six miles east of the city, near Brookville and Shortridge Roads.

Like others in the community, Brady's initial home was a log cabin that grew over the years to serve as an inn; it also included the local tavern. Not only did Brady farm, but he also presided over the first frontier school as the schoolmaster in 1826. Moorhous School was the precursor of Lowell Elementary School and was originally located at 1100 South Kitley Street.

Brady didn't stop there. He also opened a surveying business and acted as justice of the peace for the area from 1828 to 1833. In addition, he served in the House of Representatives and on the board of commissioners for the medical institution that became known as Central State Hospital.

Brady died on November 29, 1863, and was buried at a cemetery on his family homestead at 1100 South Shortridge Road near six of his children. Three of Brady's children survived childhood, and his son Oliver remained in

the area. Oliver owned a farm at 7034 Brookville Road and operated a saw- and gristmill following his military service, which included the Civil War.

Thomas Askren was another prominent Warren Township settler. Like Brady, Askren served in the War of 1812 under Andrew Jackson and eventually settled in Hamilton County, Ohio, with his wife, Mary.

In 1825, Askren arrived in Warren Township and purchased a section of land near Pleasant Run Creek and Sixteenth Street. The original structure on the property was a log cabin, and after it was built, he cleared three acres of land before returning to Ohio and bringing his family to their new home.

According to *The History of Warren Township*, Askren loaded his belongings into two wagons, and he and his family walked throughout most of their journey to the new farmstead, herding their animals as they made their way. The Askrens' new life in Indiana was a prosperous one, and it wasn't long before the cabin was replaced by a home constructed of bricks fired on the land and formed from the clay found along the creek bed. The resulting two-story home is still located on the property. Askren lived on the property until his death on July 23, 1864.

Those early settlers who made their homes in the township along with Brady and Askren were primarily farmers, but the isolated conditions proved that necessity was the mother of invention. Many of these pioneers became jacks-of-all-trades, whether it was becoming a teacher, a congressman, a civic leader, a business owner or a tradesman, in order to give the area the amenities needed to enjoy life. Before long, the community evolved from a rural farming district into an area that was becoming more urban and industrial.

Carrie Askren and her horse. The Askrens were one of the first families in the Warren Township area. *Courtesy of Mary Jane Eihacker.*

The Askren barn, which was famous for its Jersey cows. Mr. Askren was also a school bus driver. *Courtesy of Mary Jane Eihacker.*

Areas such as Irvington proved that Warren Township was far more than cabins and farms, and even properties that were largely farmland now utilized heavy machinery such as tractors, which were becoming more commonplace thanks to the industrial age. Even transportation began to change. While horse and wagon still sufficed, improved road conditions spawned toll roads, stagecoach lines and, of course, railroad travel. With so much access, it was only natural that a variety of autonomous communities began to dot the landscape.

Warren Park

Many of the neighborhood towns have been swallowed up by the expanding city limits or have changed considerably over the years. Irvington was annexed into Indianapolis in 1902, but the town of Cumberland remains its own entity. Driving along Sixteenth or Tenth Streets, travelers are greeted by nondescript signs welcoming them to the town of Warren Park.

Warren Park began with six families who lived within the area, though the official plat was not laid out by surveyors until 1913. It would take another fifteen years until Warren Park became officially incorporated as a town in the state of Indiana. According to the published history, residents of the new town wanted to remain separate from the state for tax purposes, and they

strove to keep their area from being consumed by the city. There were only about fifty homes and a few businesses in the suburban area. It was quiet and isolated and was idyllic to those who didn't intend to travel too far from their homes and enjoyed living in an area where everyone knew everyone else.

At the time of its incorporation, Warren Park was a heavily wooded area, and most of the residents enjoyed electric bills of about $1.50 per month. Wells on their properties provided them with water. Pleasant Run Creek offered recreational opportunities for the kids, who used the creek for swimming and fishing, bringing home plenty of catfish and sunnies for dinner. Even during the winter, the creek provided children a place to ice skate or play hockey when weather conditions permitted.

One of the businesses located in Warren Park was Everett L. Claghorn's grocery, which served as a community gathering spot. Folks could buy their food staples and catch up on all the social news happening around town.

"The people of the town gathered there to talk and plan things," *The History of Warren Township* noted. "They also held important meetings such as town board meetings. For many years, voting was held in the grocery store. The elder Claghorn served in the town board for three terms."

The grocery store stood on the present site of the Hilltop Tavern, at Tenth Street and Ridgeview Avenue. During the Depression, when townsfolk, similar to everyone else in the country, were suffering, the community of

Pleasant Run at Sixteenth Street, where Thomas Askren made his homestead. The house can be seen through the trees. *Courtesy of Jack Hensley.*

One of the oldest homes in the Warren Park area, this home dates back to the Civil War. *Courtesy of Mary Jane Eihacker.*

Warren Park pulled together in order to help its neighbors make do with whatever they happened to have available.

"I ate green beans one whole summer until I thought I was going to turn into a green bean," said Gordon Claghorn, son of Everett, in *The History of Warren Township*.

Though the town is small, there are a couple of landmarks in Warren Park that are noteworthy, in addition to the site of the Hilltop Tavern. The first is the large colonial home of Dr. J.P. Worley, located at Tenth Street and Edmonson Avenue. Eventually, the home was owned by the Justus family, who were known for their contributions to building all over the Indianapolis area. Another home on Tenth Street, belonging to the Vavel family, was an attraction due to the extravagant Christmas lights the family displayed every winter. According to the published history, "So many people came to see the Vavels' house that there was a traffic jam."

Aside from a notorious skirmish in 1961 involving the killing of Marion County sheriff deputy Edward G. Byrne by Michael Callahan, Warren Park has established itself as a quiet residential town. Only a few businesses and churches are located within the town limits, including the Friends Church of Irvington, Warren Park Wesleyan Church and the Gethsemane Lutheran Church.

In January 1953, Indianapolis proposed a plan to annex Warren Park, but the town board decided to oppose the proposition in favor of remaining an independent entity. While it maintains its autonomy, some city amenities have become part of Warren Park, including city water supplies, electricity and gas lines. The town is protected by the Indianapolis Fire Department, and although today the community is completely surrounded by the city of Indianapolis, Warren Park is, as described in the official history, "a world away from the world for the citizens who live there."

Pleasant Run Creek runs throughout the Eastside, giving children a place to ice skate and fish in Warren Park. *Courtesy of Jack Hensley.*

Lukas-Harold

It's hard to imagine landlocked Indianapolis as a logical location for a major naval facility, but it was precisely this oddity that made Indianapolis unlikely to succumb to an enemy attack.

In 1938, the Bureau of Ordnance realized the need for five facilities to manufacture naval equipment. With conflict escalating overseas, the government knew it needed to produce a cache of flight stabilizers, flight gyros, torpedo directors and gun sights during the days leading up to America's entry into World War II. It found the perfect location at Twenty-first Street and Arlington Avenue for a naval ordnance plant that was leased to the Lukas-Harold Corporation.

During the construction of the plant, which contained no windows and was designed to be a blackout facility with bomb-proof walls, representatives from the Norden Company in New York were sent to train men at another location on West Michigan Street. Other trainees were sent to New York for additional instruction, and by commissioning day on May 22, 1942, three thousand citizens came out to witness the ceremony and wish the new employees well.

With the United States now firmly engaged in World War II, security at the new plant was a major concern. Armed guards were on duty twenty-four hours a day to protect the equipment being produced at the site. One of those items—the Norden Bombsight—was so top secret that it was second only to the Manhattan Project in terms of importance.

"The Norden shortened the war," said Bob Pedigo in *Walking the Hardwood*, a published history of the plant. Pedigo not only helped produce the precision optical devices but also saw them in action over Germany.

Workers at the Lukas-Harold Naval Ordnance Plant gather for a meeting. Those who worked for the government were proud of their efforts during World War II. *Courtesy of Ron Huggler.*

The bombsights carried a great deal of responsibility, not only for those who manufactured them, but also for those who used them. In fact, every bombardier cadet in the air force took an oath to protect the equipment with which he had been entrusted—even if it meant with his life.

Like any wartime production facility, as men left to enlist, area women were brought on staff to keep up with demanding production schedules. Over the years, the Naval Ordnance Facility (and all of its other monikers) was lauded for its commitment to hiring women and other minorities while offering attractive wages. It's no wonder that the company drew employees from all areas of the city.

Stellar performance during the war earned the Lukas-Harold plant the prestigious Army-Navy "E" Award for war production, as well as the National Safety Award in 1944. These were only the beginnings of the many accolades that would be enjoyed by the facility.

Postwar Production

Once the war was over, Lukas-Harold converted into an official U.S. Navy shore establishment. This came as welcome news to employees, who feared that the facility may be abandoned after victory was declared. The facility was renamed

the Naval Ordnance Plant Indianapolis (NOPI). The plant turned much of its efforts to research and engineering development of aviation ordnance fire control equipment, among other projects. Of course, production slowed now that peacetime prevailed, and in October 1946, an open house was held at the facility in order to give people a chance to see "behind the walls."

The Korean conflict of the 1950s saw a rise in production once again, and even a few women returned to the site in order to lend a hand. There was a focus on expansion in terms of product development, as well as equipment and even the building of new structures on the facility site.

Change was a byword at NOPI. Funding changed from being a line item in the navy budget to projects that were paid for by individual clients ordering technology that focused on avionics. It wasn't long before the facility changed its name again as its command switched from control by the Bureau of Ordnance to the Bureau of Avionics. The new name was the Naval Avionics Facility Indianapolis (NAFI). Some of the products developed included radar components and the Mark 3 Mod 3 bomb director.

Employees at the facility concentrated on the development of avionics units and components for existing equipment, as well as new innovations. As impressive as its technological advances were, NAFI also proved to be a solid community backer, not only sponsoring sports teams, donating trophies, holding dances and organizing children's Christmas parties, but also remaining vigilant about hiring handicapped individuals and others with special needs. One of the efforts by the plant was the entry of a float entitled "Back Our Men in Vietnam" in an Indianapolis parade that took the Governor's Cup award. The award also earned the company $250, which was used to send care packages to the men and women serving in Korea and Vietnam.

By the 1960s, the space race was on, and NAFI was onboard. It continued to provide technology, such as the Walleye weapon system, to the armed forces and also to NASA, which commissioned a satellite steerable antenna for use during the famed Apollo 11 mission. Much of NAFI's concentration was on microelectronics, innovations in beam welding to accommodate a variety of metals and thicknesses and an atomic time-measuring device that would only lose one second every three thousand years.

Naval Avionics

During the 1970s and '80s, the Eastside plant was known as the Naval Avionics Center (NAC). According to *Walking the Hardwood*, the mission of the center was to:

Workers at the Naval Ordnance Plant gather for a photo. The plant was very active in the community and encouraged employee organizations to keep up morale. *Courtesy of Ron Huggler.*

conduct research, development engineering, and material acquisition, pilot and limited manufacturing technical evaluation, depot maintenance and integrated logistics support on…avionics, missile, space borne, undersea, and surface weapon systems and related equipment.

Computers were now the backbone of the facility and were used onboard aircraft electronics systems. Computer-aided design was a major component of the plant as well. NAC shifted from a production facility to a plant that offered integrated logistic support in electronics production. Some of the exciting advancements included the hybrid microelectronics facility, which encompassed the Circuit Panel Fabrication area and Assembly and Test Area.

In the early 1990s, NAC was called on to provide support to service members who were stationed overseas in Operation Desert Storm/Desert Shield. Much of the weaponry used during this conflict was designed by NAC and used onboard the USS *Theodore Roosevelt* and the USS *Midway*. Employees also took the time to rally support for the troops and organize letter-writing campaigns, as well as sending care packages.

Rumors of base closings plagued the facility throughout the 1990s. It seemed unlikely that the Naval Air Warfare Center Aircraft Division, Indianapolis, as it was now known, would escape the chopping block for long. A transition team arrived at the center to prepare employees for privatization or probable closure. In 1996, Mayor Steven Goldsmith announced that the Hughes Technical Services Company would assume control of the Indianapolis plant. It was the largest privatization of a government facility. The naval operations plant had come full circle and was once again under civilian direction.

Today, the former site of Naval Avionics is controlled by Raytheon, which is now a major employer in the community, and the grounds of the landlocked naval base remain a tribute to the blood, sweat and energy offered by workers in support of the nation's finest.

It Was a Different Time

For those who grew up in the Warren Park area and just west of Shadeland Avenue during the 1950s and '60s, the neighborhood is remembered with fondness. Chef Wendell Fowler, a local author, humorist and media personality, said that Warren Township was a wonderful place to grow up.

"We lived at 6727 Springer Avenue," he said. "The Linder family who owned Linder's Ice Cream lived right across the street from us."

Fowler recalled the days when he and his friends rode their bikes and played hide-and-seek or basketball until their parents called them in for the night. According to Fowler, the Pleasant Run Golf Course provided endless amusement, as he often snuck onto the course to play a hole or two before being run off by the golf pros.

"One time we were on the twelfth hole when a foursome of businessmen came along," he remembered.

On that hole, you have to chip the shot onto a hill, and surprisingly, they all made it onto the green so we nudged the balls into the cup. They looked all around for the balls and were surprised to find that they all had made it, but they all went along with it while we laughed our heads off from where we were hiding.

As a student at Warren Central, Fowler eventually played on the course as a member of the school's golf team. He also saw many changes coming to the area, whether it was the new Dairy Queen in Irvington or the large shopping center growing along Shadeland Avenue.

"You could look past the Askren farm and see it being built," he said. "It was enormous."

Fowler said that he even had one of his first jobs on Shadeland Avenue at the Dog House Restaurant (today's Zelma's), where he was employed as a pot washer. He also said that Warren Park and Warren Township were places where all seemed right with the world.

"You didn't have to lock your doors, and many of the families were all within a mile of each other, so there were a lot of gatherings and Sunday dinners. I had a great time living there."

CHAPTER SIX

THE SHADELAND CORRIDOR

The acquisition of a Western Electric plant on the Eastside was a coup for residents, who were eager to work at the new facility. In 1948, a site-scouting crew was sent to look at two potential locations for the proposed plant: a northwest spot at Lafayette Road and Thirtieth Street and one on Shadeland Avenue (Indiana Road 100) on the city's Eastside. The latter prevailed, and that year construction began on a site, predominantly farmland, anchored by a railroad.

Western Electric's contribution to the Shadeland corridor set the stage for the other industrial campuses that followed and emerged along the soon-to-be-evolving avenue. While the plant was under construction, Western Electric rented space across town in Speedway in order to train workers who would be employed at the new facility to produce telephones for Bell telephone subscribers. The plant opened in 1950.

Jack Hensley was one of those early employees, starting out as a weight counter before moving into inspection and, ultimately, management, working at the model shop where he oversaw the prototype of the first "picture phone." He recalled fondly his years at Western Electric, a company he said was committed to safety and stressed camaraderie among employees, even going so far as to rent out Riverside Park on the Westside for an annual company picnic.

"Some families had six or seven family members working there, it was so great," he said. "They had a number of things for employees to do after work. The Indianapolis Club was one of them. We had bowling leagues, softball leagues and were a sponsor of the first Special Olympics in Marion County."

Hensley said that working at Western Electric in the '50s was a different experience than it is for people who work in factories today. He said that the company expected its employees to put in an honest day's work for an honest day's pay, and in addition to the working conditions, the benefits were hard to beat.

This dilapidated barn and field on Shadeland Avenue would eventually hold one of the largest facilities on the Eastside, the Western Electric Plant. *Courtesy of Jack Hensley.*

A construction shot of the Western Electric Plant from 1949. The plant was a huge boost to the neighborhood and offered many employment opportunities. *Courtesy of Jack Hensley.*

"I started out making one dollar an hour less taxes and I still had money to buy gas, pay my room and board and still had money left over to date and buy clothes," he said. "Of course, that was a different time."

Those who worked at the Western Electric facility had a work ethic that was felt throughout the plant. As a result, there was a low turnover rate among employees. Hensley said that while workers came from all over the Central Indiana region, a fair number of those who worked along Shadeland Avenue wanted to relocate to the Eastside and expected there to be plenty of amenities nearby. To accommodate a growing need for housing, retail

and infrastructure, builders constructed the postwar homes like the one Jim McGuinness's family moved into, and the city began to widen Shadeland in order to solve traffic problems.

"It wasn't long before the car manufactures moved to Shadeland as well, and then you had the dealerships nearby," recalled Hensley. "I thought the whole automobile industry was moved to Shadeland and then Eastgate came along. Everyone wanted to be close to the plants and still have all that they needed in convenient locations."

With eight thousand people in its employ, Western Electric had one of the largest payrolls in Indianapolis, but the breakup of the AT&T monopoly created many changes that affected the Western Electric plant. In 1983, it was announced that the facility would close, and many employees were relocated throughout the country while others were laid off.

"It affected a lot of people in different ways," said Hensley.

> *Those who had more than twenty years in were able to relocate. I had the opportunity to go to seven different states, but I had a son who was a senior in high school and we didn't want to uproot the family. Some who transferred had a difficult time in their new jobs.*

The Western Electric plant remained empty for a period of time and now serves as an office park for a variety of companies. It wasn't the last plant to come and go on the Eastside.

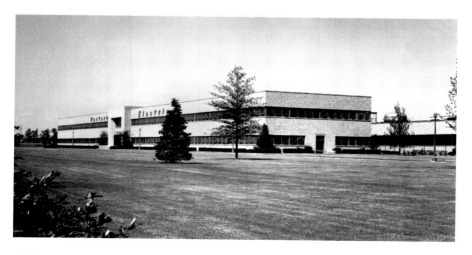

A finished shot of the Western Electric Plant. The building remains and is now used as an office park. *Courtesy of Jack Hensley.*

Automotive Giants

Thanks to Western Electric's presence on the Eastside, it didn't take long for the automotive industry to see Shadeland Avenue as an attractive location for parts plants. Chrysler began construction on its factory in 1950, with plans to manufacture automobile transmissions three years later. Eventually, production centered on distributors, starters and other electrical parts.

The facility at 2900 North Shadeland Avenue (across the street from the Western Electric plant) took up eighty thousand square feet with a parts depot nearby. Like Western Electric, Chrysler and Ford were major employers to folks on the Eastside, as well others throughout the Indianapolis and surrounding areas. Chrysler employed as many as thirty-five hundred people during its heyday in the 1970s, and Ford was responsible for about four thousand employees.

Ford, of course, was no stranger to the Eastside. First opening a sales office in 1910 for the famed Model T, the first factory was a four-story, 175,000-square-foot building on East Washington Street. *The Encyclopedia of Indianapolis*

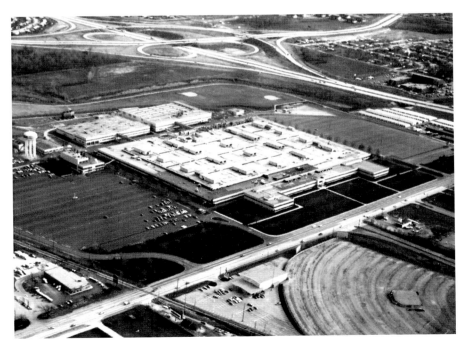

This overhead shot of the Shadeland corridor shows the growth and expansion on the Eastside. I-70 can be seen as well. *Courtesy of Jack Hensley.*

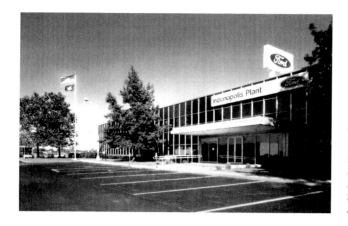

The Indianapolis Ford Plant boasted an impressive workforce at its facility located at English and Kitley Streets. *Courtesy of Shane and Jan Dye.*

said that the Ford Company "erected the buildings on Washington Street as a regional center where cars would be assembled, sold and repaired." Though sales at the location ceased in 1916, the cars were assembled on that site until 1932.

Of course, the Ford plant most associated with the Eastside was the facility at English and Kitley Avenues, just off of the Shadeland exit. Built in 1957 and nine times larger than its previous plant, the building was over one million square feet. According to *The History of Warren Township*, the Ford plant, like the Chrysler facility, was designed not to produce automobiles themselves but rather to specialize in the manufacturing of steering gears, columns and pumps for cars produced under the Ford and Lincoln Mercury names.

It's no surprise that with the automotive industry playing such a huge role along the Shadeland corridor, dealerships would abound, too, offering the crème de la crème in American automobiles. Hensley called the corridor, due to the presence of so many car manufacturers, "automobile alley."

But the good times were not meant to last. In 1987, now employing only twelve hundred people, Chrysler announced the closing of its Eastside facility due to outdated tools and the expense of its line of products. Most of the employees were relocated, but with Western Electric having closed only a few years before, it was a hard blow for Eastsiders who depended on the factories for employment. Transfer often meant moving out of state, which, in turn, meant more home sales in the adjoining neighborhoods. It wasn't long before car dealerships merged, and in recent days, only a handful of Detroit's biggest names dot the corridor, which was once dominated by Chevrolet, Dodge, Chrysler, Jeep and others.

"In 1992, Ford upgraded part of its plant so that it could supply power steering units for cars made in Europe," noted *The Encyclopedia of Indianapolis*.

"Ford spent $150 million on the improvement and received a $40,000 state grant for job training along with $20 million in tax abatements over a five-year period."

"My father worked there for forty-five years," said Shayne Dye, owner of the Tie Dye Grill. "I started working there in 1998, and my wife, Jan, started in 2000. I tested power-steering pumps before moving on to rack and pinion for Lincolns, Grand Marquis and limousines."

The Dyes said that they were proud to work for the Ford Company and recognized its important contribution to the Eastside community. Though they both took buyouts and opened their own successful restaurant on Shadeland Avenue, they said at least the plant is there, even if it no longer bears the Ford name.

"It was Visteon for a while and now is Automotive Components Holding Group," Jan said. "Still, it's not the same as it once was."

Eastgate Shopping Center

In the 1950s, the manufacturing plants were alive, and there was a need for retail stores on the Eastside. The inventive solution to the problem was a shopping center, known as the Eastgate Shopping Center, on 40.6 acres of land along U.S. 40 and Shadeland Avenue. Eastgate was a thirty-seven-thousand-square-foot open-air facility that opened for business in 1957. It was designed to provide one-stop shopping for area residents. This was the first "malled" shopping center, though Lafayette Square opened a few years later and had the distinction of being the first enclosed shopping center.

Eastgate was a coup for the people of the Eastside. Now residents could visit as many as forty stores without having to trek all over the community or catch the bus to the downtown department stores. Those in the suburban areas had shopping options right in their own backyards, and the result was nothing short of phenomenal.

"We tried to go to Eastgate the first night it opened," said Virginia Williams, who lives in Morristown. "It was so crowded that we couldn't find a parking place and we had to turn around and go home."

With stores such as Wasson's, J.C. Penny, Sears and Roebuck, Hudson's, Levinson's and Rost Jewlers, customers had their choice of high-end merchandise, along with dime store options such as Woolworth's and G. C. Murphy's. Greg Bierck remembers the early days of Eastgate with great fondness, primarily because he no longer had to travel downtown with his mother in pursuit of his yearly Easter outfit.

People came from miles to visit Eastgate Shopping Center, the first "malled" option in the Indianapolis area. *Courtesy of Eastgate Neighborhood Association.*

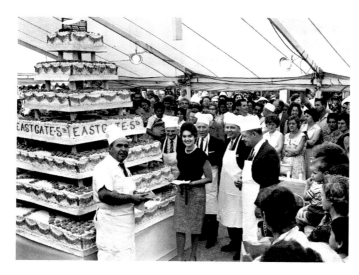

Eastgate staff and guests celebrate the center's fifth anniversary with a giant cake. *Courtesy of Eastgate Neighborhood Association.*

"I hated going shopping because mom would always say 'just one more place' and five or seven shops later, there would be just one more stop," he said in *The Jennifer Letters.* "Eventually Eastgate Shopping Center opened with breezeways to walk under from one store to connecting store. These places became very popular rapidly, and individual stores could not compete."

Eastgate became a destination for people who wanted to see the spring styles or circus acts, which were often set up on the parking lot during the summer months. Bierck said he remembers occasions in which the National

Guard would land its choppers on the ground and let kids get their pictures taken inside the helicopters. Photos from the early days of the mall depict camaraderie among folks who enjoyed having an amenity such as Eastgate in the community. The attraction drew celebrities such as the Cisco Kid, along with local talent and organizations that hosted shows, talent contests and fun for all ages.

Bierk remembers:

> *Eastgate had an auditorium that might have held a few hundred people. My sister and I were both there with my mom and they had some kind of drawing going on for toy dolls. They picked volunteers to come up on stage from the audience to draw names out of a box. I was chosen and...I pulled out my sister's name so she won the doll.*

On deadmalls.com, a user named "Brian" recalls the days of shopping at Eastgate when he used to buy his sneakers at Wasson's department store, hoping to hurry the trip along so that he could get to Sam's Subway Cafeteria across the way.

> *You could see Sam's outside the display windows and you could smell the spiced aroma of Sam's deli meats drifting through those revolving doors with every entering Wasson's customer. Sam's was as close to heaven as this five-year-old could understand.*

When Washington Square Mall was established farther east in 1974, it was an enclosed mall like Lafayette Square. Eastgate's owners saw fit to cover the Shadeland mall as well. According to Sharon Tabard, president of the Eastgate Neighborhood Association, just as Eastgate drew some businesses away from Washington Street in the 1950s, the new, shiny mall at Mitthoeffer Road and Washington Street drew the larger retailers. This left only smaller stores behind.

During the latter part of the 1970s and early '80s, Eastgate appeared to be a ghost town and only a shadow of its former self. The mall received a bit of an overhaul in 1981, when the Simon Property Group bought Eastgate and made plans to find a niche consumer for the mall. The result was the Eastgate Consumer Mall, an early outlet facility that was anchored by Burlington Coat Factory and included such stores as Linens 'n' Things, Hallmark and Luca Pizza, along with longtime tenant Woolworth's.

Still, other anchor stores were hard to come by, and the best that could be secured was a discount drugstore. Though outlet shopping would come

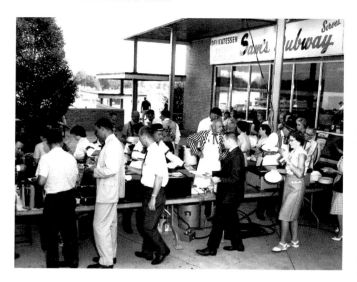

Left: Sam's Subway shop was a must after a big day of shopping. In this photo, Sam's participates in a pancake breakfast. *Courtesy of Eastgate Neighborhood Association.*

Below: Washington Street signage for Eastgate Shopping Center. The Ace Motel can be seen in the background. *Courtesy of Eastgate Neighborhood Association.*

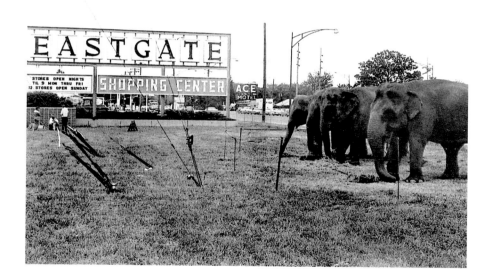

into vogue in the '90s, it appeared that Eastgate's life as a mall was over. That became even more evident when Burlington Coat Factory moved to Washington Square.

"What was Eastgate's final death blow?" asked Brian on the deadmalls. com website.

A name associated with dead malls everywhere. North Carolina–based Haywood Whichard. Whichard bought Eastgate from Simon in 2002 —leaving Eastgate to die. While Whichard owed the City of Indianapolis close to a half million dollars in back property taxes, he continued to look for a buyer. He didn't find one, and the City of Indianapolis scheduled Eastgate for an October 2004 tax sale.

"Now, of course, malls are being built again as open air like Eastgate was," said Bierck. "What comes around goes around and what made Eastgate such a destination was also its downfall."

At present, Eastgate is getting another extreme makeover in the form of a private company that intends to use the property as a data center in a few years, though the opening date of that site is still unknown at the present time. Brian suggested that the decline of Eastgate is yet another casualty of the decline in Eastside infrastructure, but the truth is, there is still plenty of life left around the former mall, including the Ransburg branch of the YMCA and the Holy Spirit Catholic Church and School, along with several small strip centers with lots of service and retail offerings.

Local radio personality and Hoosier historian Nelson Price said that his first paying job was at the Y when he was sixteen years old. He worked as a lifeguard:

Swimming has been my lifelong passion, and it all started at the Ransburg YMCA where I learned to swim. During the summers my mom would take my brothers and me to the Y in the late morning and we would stay there for an entire eventful day.

Price said that he is thrilled to see the Eastside YMCA thriving and surpassing what he considered to be its heyday back in the 1960s and '70s with its reinvention as a fitness center with an array of cutting-edge options for enthusiasts. He said that it is a thrill for him to return to the Eastgate neighborhood and see plenty of wonderful things still happening around his old stomping grounds.

"The Eastgate Neighborhood Association was formed in 1988 and I have been the president the entire time," says Tabard. "We have approximately twelve hundred homes and numerous businesses within our boundaries. Many of our residents have lived in their homes for forty to fifty years. We have great things going on over here."

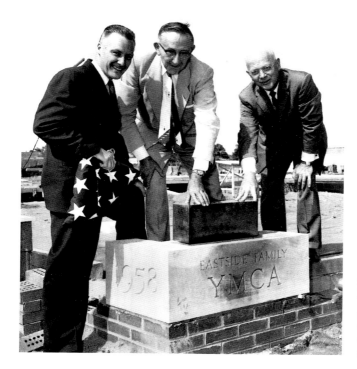

Left: Board members of the YMCA lay the cornerstone on the Ransburg YMCA building at Shortridge Road. *Courtesy of YMCA of Greater Indianapolis*.

Below: The finished Ransburg YMCA building, which still serves the community today. *Courtesy of the YMCA of Greater Indianapolis*.

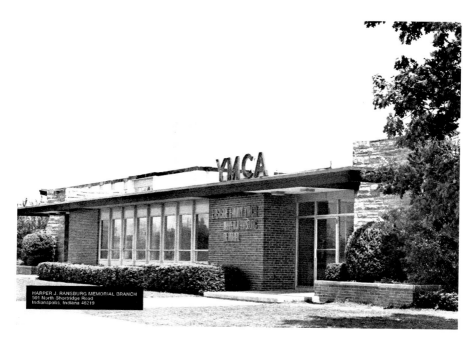

Nothing beats a cool dip in the YMCA's indoor pool, whether it is open swim or lessons. *Courtesy of YMCA of Greater Indianapolis.*

Al Green's

One of the businesses on the Eastside to which Sharon refers became legendary in its own time: Al Green's Famous Food Drive-In. Established in 1947 as a family-owned venture, Al Green's was located at the corner of U.S. 40 (Washington Street) and Shortridge Road.

Al Green graduated from Indiana University in 1940 and served as a cook in the U.S. Army during World War II. When he returned home after the war, he (along with his father, his brother, Nate, and his sister, Belle) opened the drive-in on eight acres at 7101 East Washington Street, complete with an octagon-shaped, Pepto-Bismol-pink stucco building and a giant "seven"-shaped sign that, at night, lit up U.S. 40.

"My dad used to say that when they came into Indianapolis from Charlottesville, you could see the neon from Al Green's for miles," said Shane Dye. "That makes a lot of sense because back then, there wasn't anything else out here."

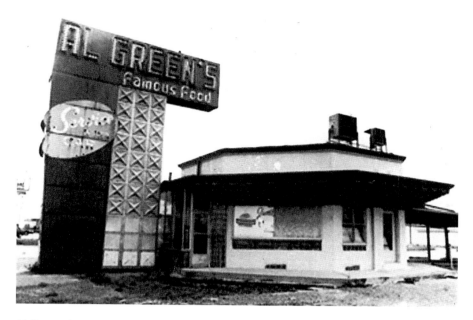

Al Green's Famous Food was a staple on the Eastside for many years. Belle and Al made all their guests feel welcome. *Courtesy of Ron Huggler.*

With nowhere to eat for miles and offering a welcome respite for tired travelers, Al Green's provided customers with an opportune place to get a "quick" bite at a fair price. Al Green's boasted the largest free-standing sign in America, but also, in 1953, he became the first drive-in operator to offer a telephone ordering system from the car. Corporations cropping up along the Shadeland corridor and along U.S. 52 also welcomed Al Green's, and employees of Western Electric, Jenn-Air, Chrysler and International Harvester often stopped in for lunch, eating a generous portion of fries along with oversized tenderloins. Still, it was the kids of Warren Township who made Al Green's a popular hangout, where they could "buzz" the parking lot and watch the movies for free on the outdoor screen.

"Al Green's rose above its peers for several reasons," said Pete Tocco, web administrator for the site www.algreensdrivein.com. "Its architectural flair, personal service, specialty food, free movies and key location all helped it attain legendary status."

Green himself talked about the amount of people who came to the drive-in from all parts of the country. In fact, in the 1950s it was nothing for there to be four hundred cars after the dances or area ballgames. Though the phone service was supposed to expedite meals at Al Green's, "fast" food proved to

The outdoor theatre at Al Green's was a spot to catch an old flick or a place for hot rod clubs to get together. *Courtesy of Bruce Gable.*

be a fluid concept, and customers were content to wait two or three hours for their orders. The notice "Same Day Service" was promising—it allowed many customers who had to wait out their order in the parking lot to be with their friends.

"It took forever to get your food," said Sandy Denton, who remembered going to Al Green's in its heyday. "I remember getting the tenderloin, but you weren't supposed to be concerned with how long it took to get your food. You were supposed to hang out and watch the movies until the food got to you."

Even Green's sister, Belle, used to tell customers to bring a peanut butter sandwich to eat while they waited in the drive-in's later days. Green himself was more content to catch an Indiana University basketball game rather than tend the grill, and while his brother, Nate, was alive, he used to drop everything and jump in his car when he saw a fire engine going down the road, leaving the French fryer sizzling in his absence.

Nate Green was also responsible for running the projector for the movies, which might include an hour of cartoons, along with some of his brother's favorite films such as *Yankee Doodle Dandy*, *Creature from the Black Lagoon* or *The Hunchback of Notre Dame*. Nate himself was a Guy Lombardo fan, much to

the chagrin of the patrons, and he often napped in the booth. Occasionally, certain customers were allowed to stand guard in the booth in order to nudge him if he started to nod off.

"We never let the girls go up," recalled Al in an *Indianapolis Star* article.

Despite the success of the drive-in, Al Green's suffered a bit as the late 1960s and early '70s brought about changes in society. The family slowed their already leisurely pace, and when I-70 became the hub of traffic activity, Al Green's no longer enjoyed a prime location. The building of the cloverleaf at Shadeland Avenue and U.S. 40 also posed a problem for Green, who had issues with the cloverleaf construction and the resulting fence that blocked his main entrance. The fact that the family remained rooted to their spot spawned several rumors, ranging from secret wealth to gambling operations during the day, and a persistent theory that the state paid Green each year that he occupied the land.

"It's fairly well documented that he was living there," said Tocco.

> *By the time I arrived at Al Green's in the 1970s, it was rundown and a little creepy. The hours of operation were irregular, the movies were only shown once in a while, many speakers did not work and the place was in general disrepair.*

Tocco said that Al's still enjoyed several regular customers, consisting mainly of high school kids and a few old-timers who happened to be hanging around. Tocco felt that a large part of the popularity of the place was due to the personality of Green's sister, Belle, who was known for greeting each person by name and often dispensing advice to the lovelorn. Most people didn't realize that she had enjoyed a career as an elementary school teacher in Michigan before accepting a position as a dietician for Riley Hospital.

"At the time, it seemed she was playing the role of talk show host and we were her important guests," Tocco noted.

Leo Foster did some part-time electrical work for Green and submitted his recollections to Tocco's website. Foster recalled that Green's family emigrated from Russia, and Green himself became the boss of the restaurant by way of being the oldest. During the restaurant's heyday, Green lived in a home that was just north of the railroad on the same parcel of land as the drive-in. Foster mentioned that the Greens were never too worried about their competition and preferred to let their food do the talking. Foster said that the decline in the drive-in was natural, based on the needs of the customers rather than the progress of anything being built around it.

"Most of his trade was with the young people out for an evening," he said.

Rodney Phelps worked for Al Green for one dollar and hour while he was in dental school. Eventually, Al, Nate and Belle all became patients of Phelps, in addition to good friends. Rodney's wife, Shirley, said that Green would make a corned beef brisket for the couple to take to a New Year's Eve party they attended each year. She recalled:

> *They were very interesting people and extremely private. I do know that Al and Belle chose to live in the restaurant for a while toward the end, and I did hear that the state made a deal with Al when they cut off his access to Washington Street after the cloverleaf was constructed, but it wasn't something that they talked about a lot. We were just good friends with them and Belle was even at our wedding. I still have a necklace Nate gave me a long time ago.*

In the '80s, Al Green's became a haven for classic car clubs that often met in the parking lot. Green and his sister had a cache of customers that sometimes spanned four generations, and it wasn't uncommon for couples to return to the drive-in to revisit their teenage years. Green's regulars, usually an older generation, would sit around and reminisce about old times, when the kids with the money parked up front and those who were broke parked in the back.

Not one to allow time to dictate when he should leave, Green kept the drive-in open until the property was purchased and paved over by a car dealership, which occupies the space today. But for those who visit Tocco's site, Al Green's is a legend that lives on.

"Not a day goes by that I don't get hits on that site," he said. "Al Green's meant a lot to a lot of people."

THE FAR EASTSIDE

The Shadeland corridor and Eastgate certainly blew the door open for progress beyond Road 100, but those who enjoyed life in the predominantly rural setting were happy with their quiet lives, despite the steady beat of progress constantly moving toward them. The Far Eastside would not remain a rural area for long.

Township Schools

Indiana's state constitution made provisions for a system of education beginning at the township level and working toward state universities, and for Warren Township that meant dividing up the area into nine districts where schools would emerge, beginning with the first school at Thirtieth Street and German Church Road and the second on Shadeland Avenue. Of course, there had been a few one-room schoolhouses and subscription schools prior to this, but these district schools were the backbone of what are the Warren schools of today.

All of the schools have illustrious histories. Lowell Elementary, or School No. 9, is a standout for its longevity. Lowell, built in 1827 on the Moorhous farm, is the longest continually operating school in Warren Township. The original frame schoolhouse building was used until 1872, when it was moved to Raymond Street and was used as a home. A new schoolhouse was in order at Raymond Street and Hunter Road. According to the *History of Warren Township*, by 1904, as many as forty children were enrolled at School No. 9, though there were five other schools within the district.

Children attended class by either walking to the schoolhouse or riding their horses, tethering them to the hitching post outside of the school. Mrs. Epha Johnson was the teacher at School No. 9, and she handled the education of all eight grades, as well as performing the janitorial duties, for $2.85 a

week. Education was changing with the times, and Mrs. Johnson not only concentrated her curriculum around the "three *R*s" but also saw the need for flag drills and demonstrations. The school received its own piano, and the following year Mrs. Johnson and her graduating class decided to rename the school Lowell after the poet James Russell Lowell.

In 1914, another expansion demanded a new building, and this time a two-story brick structure was built to accommodate the sixty students who attended classes at Lowell. At this new facility, children were able to enjoy food service, with older young ladies serving the daily meal and cleaning the dishes.

Schools in Warren Township were more than buildings of learning; they also served as the social epicenter of the community. With so many farms nearby, the schools provided a natural place to hold talent shows, dinners and bazaars. Throughout the township, schools were flourishing, including the Shadeland School, Cumberland School, Davis School and Township House. Crowded conditions in the early part of the century forced the trustees to think about how best to accommodate older students in order to free up space on the elementary level.

Warren Central High School

Warren Central's history began with the consolidation of the Shadeland and Cumberland Schools in 1924 in order to form a community high school. Edward J. Hecker is credited with the founding of the high school to help alleviate the crowding in the other schools (noted by the 108 new students who arrived that year alone). He reasoned that new families in the area meant the need for more educational space. His idea of a centralized high school also made sense because of a state law that said if students could not get to a township school, the trustees had to pay the tuition for the student to go elsewhere. This was costing as much as $5,000 annually.

Hecker realized that additions to the two other schools could provide one solution to the issue, but he also felt that building Warren Central, which would accommodate grades seven through twelve, might be the best solution to the situation. Hiring Cornelius E. Eash to be the first principal, construction began at Tenth Street and Post Road, with plans to open the school in the winter semester of 1925.

Though the dedication of the building wouldn't happen for several months, the first full day of classes in the new Warren Central High School building occurred on January 12, 1925. Students and staff alike were impressed with

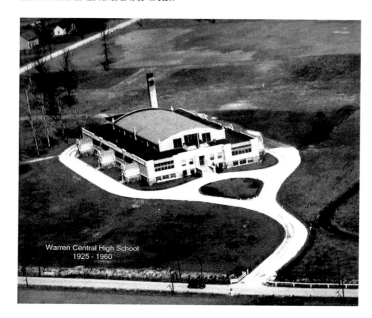

The Original Warren Central High School building at Tenth Street and Post Road, constructed to meet the growing needs of Warren Township. *Courtesy of Warren Central High School.*

the spaciousness of the new school, which was situated on nineteen acres of land and contained thirteen classrooms on the main floor, along with basement facilities that accommodated science labs, manual training classes and domestic science classes.

Local newspapers lauded Warren Central, claiming that the new high school gave rural students the same opportunities enjoyed by city children. The community was also firmly behind Warren Central, and early additions were planned for the campus, such as a parking lot, sidewalks, landscaping and other beautifying efforts. In 1939, the school commissioned murals by Harold McDonald that depicted Indiana history. Students sold candy to raise funds for the artwork, which cost $12,000.

The History of Warren Township outlines the many traditions and innovations that Warren Central established in those early years as the needs arose. Additions were made to the building, and teachers were constantly looking for ways to improve curriculum so that not only were the basics taught, but also a variety of enrichment classes were added that made Warren Central a standout in education and gave students an edge.

Student clubs, parents' organizations, the *Owl* newspaper and other extracurricular offerings were developed throughout the late 1920s and early '30s, including the addition of adult education classes, which were held every Tuesday evening. The student population showed no signs of slowing down; however, when World War II broke out, many Warren Central students left

to enlist. Their school did not forget them. School papers were mailed to the GIs serving overseas, and the students who were left behind supported the war effort by purchasing war stamps and thousands of dollars in war bonds. The physical education department even offered a "Victory Corps" class designed to prepare young men for the rigors of military service.

A decade after the end of the war, Warren continued to expand and change, though the biggest change was yet to come: the construction of a new school building. The push for the new school began in 1959, after it was predicted that the student population would reach twenty-five hundred by 1960. School board president Albert Anderson suggested that the existing building should be used as a junior high for grades seven through nine, with the new construction housing grades ten through twelve. The new building was to be located on fifty-seven acres at Sixteenth Street and Post Road and paid for with $3.5 million in bonds, which were sold for the construction. Groundbreaking took place on May 21, 1959.

Classes commenced at the new building on September 6, 1960, with Woodview Junior High opening in the old building that same month. The new high school rivaled North Central, which was the largest high school in the state. Warren Central boasted a gymnasium that had seating for four

Today's high school stands at Sixteenth Street and boasts a modern facility, as well as a career and vocational center. *Courtesy of Warren Central High School.*

thousand, a seventy-five-hundred-square-foot cafeteria and a school library that held twelve thousand books. Within a few years, there was a well-appointed athletic facility as well.

By the end of the decade, twenty more classrooms were added, along with a swimming pool. Nelson Price said that his years at Warren Central were very enjoyable and offered all students plenty of advantages.

"In the mid-1970s, North Central was the largest high school and regarded as the Cadillac of Hoosier schools," he said. "Battling for the number two spot were Warren Central and Ben Davis."

Becoming Jane

Price admits that big schools aren't for everyone, but he said that Warren Central offered students a variety of extracurricular activities and the opportunity to make lifelong friends.

"We lived on Eaton Avenue just south of Sixteenth Street in a neighborhood called Tempo," he described. "I grew up about two blocks from Jane Pauley."

Though a few years older than Price, Pauley is one of Warren Central's most distinguished alumnae. She became the noted NBC-TV broadcast journalist, known for her work at the anchor desk of the *Today Show*. Price said that he remembered Pauley as a standout from day one:

> *I attended every school that she did, from Moorhead Elementary School to Woodview Junior High, through Warren Central and IU Bloomington, always following in her wake in communications/media. Jane reaped statewide glory for Warren Central, being named "Governor" of the Girls state competition. By the time I entered Warren Central, she was co-anchoring our Channel 8 weekend newscasts, and when I was at Indiana University in 1976, Jane was named to replace Barbara Walters as co-anchor of the* Today Show, *so she was an Eastside legend, particularly for those of us who aspired to careers in the media.*

Years later, Price had an opportunity to interview Pauley at her NBC-TV offices for the *Indianapolis Star/News* while she was hosting *Dateline NBC*. He said that she was as warm and welcoming as he had hoped:

> *We clicked as fellow Hoosiers—more specifically as fellow Tempo kids. The first ten minutes of my initial interview with her in Manhattan were*

spent chatting about her friends' kid brothers and sisters, who were buddies of mine. When I do PTA-sponsored presentations about famous Hoosiers, kids ask me who my favorite is, and I have to fess up that it is Jane Pauley because of the Eastside neighborhood connection.

Far Eastside Amenities

For those children who lived on the Eastside, there were exhausting debates about which recreation center offered kids the most in terms of amenities. Price said that families in the area were members of the Y or the Mirmar Club. While the Y remains as a popular Eastside hangout for kids, the Mirmar is long gone, yet its memory lives on in those who fondly remember sun-drenched days at the club.

Greg Bierck said that the Mirmar Club was a private and segregated club that offered not only swimming but also dances in the social hall. Though Broad Ripple's pool was still the biggest, families with no air conditioning found the Mirmar a welcome relief during the summer. Bierck was on the Mirmar swim team and spent most of his summers waterlogged at the Mirmar pool.

"Little did we know at the time that the swimming team would be our year round life for the next 15 years. In the summer we would have practice at 7 a.m. before the pool was opened to the other members," he wrote in *The Jennifer Letters.* "During a season, we would easily swim the distance between Indianapolis to Chicago, while our moms would sit and gossip playing cards and drinking coffee."

Bierck even scored his first job at the Mirmar, serving as a lifeguard for $1.60 an hour. He said that the Mirmar provided a great place to make some money, meet girls and save lives. He wrote:

> *I did have about five pullouts in the deep end. The worst job was the baby pool which had toddlers, and one had to watch closely as some moms did not...lifeguarding sure wasn't* Baywatch. *Eventually the Mirmar fell on bad times and was bulldozed flat except for the clubhouse which became a warehouse. They built a strip mall where the pool used to be and it is really sad for me to even drive by there today as so much of my life happened there.*

For those looking for a great night out, it would be hard to top Mickler's Sirloin Inn on Washington Street or the Paramount Music Palace. The Sirloin

The Mirmar Club was the Far Eastside's swimming club and a place to cool off during the years before air conditioning. *Courtesy of Greg Bierck.*

The Mirmar pool was a large aquatic facility that could hold as many as three thousand people in the summertime. *Courtesy of Greg Bierck.*

The Mirmar moms got together to play cards and gossip while their children played in the outdoor pool. *Courtesy of Greg Bierck.*

Inn was known as a picturesque restaurant with great food and personalized service that always made for a memorable occasion. According to a 1964 *Indianapolis Star* article, the cuisine at the Sirloin Inn was "American with epicurean touches that are usually associated with exotic fare." Favorites on the menu included "Beefsteak of the Sea" (broiled halibut steak), as well as the "Texas Snack," known for being the largest steak in the house.

The Paramount Music Palace offered the young and the young at heart something truly spectacular. The pizzeria and vintage ice cream parlor made any visit extremely kid friendly, but the big draw was the "Mighty Wurlitzer" organ, which seemed to inhabit the very walls of the restaurant. According to the Roaring '20s Pizza website (the Florida restaurant that now houses the grand organ), the Wurlitzer was installed in the Paramount Theatre in Oakland, California, in 1931 for $20,000. The Eastside purchased the organ from Ken Melody's Inn in Los Altos, California, and it was enlarged considerably by the Chrome Organ Company. Not only could guests hear old standards like the "Chattanooga Choo-Choo," but children got a thrill when they heard selections from John Williams's *Star Wars* score, complete with the Imperial Fanfare and the "Cantina Song." Needless to say, the organ inspired a number of musicians, including Jim Vogleman and Jelani Eddington, who first fell in love with the pipe organ after visiting the Eastside venue.

Washington Square

In 1974, the presence of Eastgate Shopping Center wasn't enough for Eastsiders who wanted to be able to compete with Lafayette Square and other "malled" shopping centers. Edward J. DeBartolo Sr. built an enclosed retail center at the corner of Mittoeffer Road and Washington Street to accommodate shoppers on the Eastside of Indianapolis, as well as nearby communities such as Greenfield, Cumberland and New Palestine. Anchors for the new mall included the William H. Block Co., J.C. Penny, Sears and L.S. Ayres, but eventually, as one or another of the original anchors left, Lazarus, Montgomery Ward, Macy's, Dick's Sporting Goods and Target joined the mall.

Many blamed Washington Square for the death of Eastgate as a retail hub. According to deadmalls.com, many of Eastgate's early tenants moved to Washington Square, and those that remained went out of business or directed customers to local stand-alone locations. Others saw Washington Square as the place that took businesses away from downtown locations such as Greenfield, which lost its Sears department store when Washington Square was built. Some say that it was the construction of I-70 through the Eastside in 1963 that changed the landscape. Rosalie Richardson of Greenfield Historic Landmarks said that I-70 was a help and a hindrance to those in the outlying areas.

A *Greenfield Daily Reporter* article noted:

> *Towns built along highways like U.S. 40 built their downtown areas around those roads and relied on travelers to support businesses. The first casualties were eateries and hotels, and eventually people stopped going downtown and business started cropping up near access points for the interstate. Those access points create a secondary downtown area for towns.*

Bill McCleery, a reporter with the *Indianapolis Star*, has been an Eastsider most of his life. He grew up on the 2900 block of South Sheridan Avenue at a time when there was a lot of farmland remaining in Marion County. His first school was the noted Lowell Elementary, where he was taught physical education by Paul Ruster, for whom Ruster Park is named.

"I remember the day that the principal announced over the intercom that Mr. Ruster had died," he said. "To this day, I am not sure of the cause of Mr. Ruster's death, but I know he was a relatively young guy. He was very outgoing and well liked by the students."

Eventually, McCleery's family moved to Hancock County, but he still spent a lot of time at the Washington Square Mall, where he shopped, ate and had his first job as a teenager at Chick-fil-A:

> *I stayed there for about a year until I got a job at the Finish Line. The mall was one of our primary social gathering places during the 1980s. I'd hang out in the arcades with buddies from school and we'd play games like Pac-Man, Centipede and Donkey Kong and eat at places like Hot Sam and the corn dog place.*

Today, with new shopping centers cropping up along other interstate access points at Allisonville Road, Keystone at the Crossing and the new Hamilton Towne Center, Washington Square is a shadow of its former self, and once again small downtown mom and pop shops are en vogue. Owned today by the Simon Property Group, Washington Square continues to try and attract new tenants, not just in the mall center, but also in outlying strip malls that have continued to develop in recent years and offer Eastsiders plenty of retail, service and dining options.

McCleery said that he still spends a lot of time at the mall shopping with his family and enjoying the Friday night cruise-ins held in the mall parking lot during the warmer months:

> *The cruise-in is a nice place to get to know other people who share an interest in old cars. I prefer old original cars as opposed to the customized street rods, but it is still a cool place for car buffs to mingle, and a neat Eastside tradition.*

"I always hate it when people act like there is nothing going on here on the Eastside," said Jan Dye. "We still have plenty to offer, and there are a lot of good people over here who want the Eastside to do well. It may seem like we are down, but we are far from out."

EPILOGUE

John Mellencamp wrote, "I cannot forget where it is that I come from" in his hit song "Small Town," and as I put the finishing touches on this book, I have discovered that his truth holds a lot of meaning for me when I think back on my own Eastside upbringing. Throughout the course of writing this book, people have asked my opinion about the Eastside, and I have come to the conclusion that the people who settled the Eastside, for the most part, were visionaries. Many of them were ahead of their time, creating businesses, homes, communities, schools and infrastructure that have lasted well beyond what even they could have imagined.

Any older side of town is sure to experience growing pains when it has accomplished so much, and then, little by little, the winds of change are upon it. Some neighborhoods, such as Woodruff Place, Fountain Square and Irvington, will always have a following thanks to those people who have a hankering to live in a retro-style or historic area, but others aren't as lucky. In a recent *Indianapolis Monthly* article, Little Flower was named one of the "Best Neighborhoods You've Never Heard Of," so I know for a fact that the Eastside still has a lot going for it.

I think it is important that the Eastside focus not on the way things used to be but rather on the way things can be, and I am seeing this kind of spirit every day, with the recent re-plantings at the Shadeland Cloverleaf; Warren Pride Clean Up Day in April; the announcement that the Eastside will receive a bit of a makeover in time for the 2012 Super Bowl, which will be held in downtown Indianapolis; and the *Extreme Home Makeover* team arriving in the Martindale-Brightwood neighborhood, which has been like a "shot in the arm," according to one resident. The *Indianapolis Star* reported that Estridge builders, the show's community partner, did not stop with the building of the house at 2356 North Oxford, but it also assisted the neighborhood by planting trees, paving neighborhood alleys and arranging for free Internet access.

"It makes people feel like somebody cares," said Esther Birden. "This will give people the incentive to give something back themselves."

Though some of the time-honored landmarks have faded into history, the Eastside has a proud tradition and rich history that cannot be denied, a history whose final chapter has yet to be written. Community commitment to the Eastside is something to be admired. Those who open businesses in Irvington are sure to earn the support of locals, and there are those, such as Jan and Shayne Dye's Tie Dye Grill on Shadeland, who make a point of supplying their restaurant almost exclusively through Eastside vendors. Sandy Taylor's Hart Bakery has been a staple in this area since 1946, when it was owned by Joe Wuest. He moved the bakery to its current location at Tenth Street and Shadeland in 1958, and it has served multiple generations of customers who have a yen for something sweet. Jim McGuinness told me that he remembers working at the bakery in the early morning hours before heading to Scecina High School for class and delivering the *Indianapolis News* in the afternoon. In his administrative role at Scecina, McGuinness has remained connected to the Eastside, in addition to being involved with local businesses and employers that hire students and graduates of not only Scecina but also Tech, Howe, John Marshall and Warren Central.

Those who live, work and play on the Eastside are not only well connected, but they are also a very interconnected group. Not a day goes by when I don't run into people I know or went to school with at the local restaurants, shopping venues or while working out at the Ransburg YMCA. In fact, one lady who is frequently next to me on the elliptical machine is such a champion of the community that she often says, "Say your zip code loud and proud!" It's nothing for people to live in Woodruff Place, go to church on the Far Eastside and work in other Eastside neighborhoods whose businesses have been a staple in the community for decades.

What began as wooded farmland has grown and evolved into urban infrastructure that would make those early settlers proud, and I have no doubt that the Eastside will continue to change with the times. As my *Indianapolis Star* colleague Bill McCleery noted, "Almost all areas experience periods of positive growth and periods of challenge...I believe the Eastside still has an awful lot going for it, and it continues to be a great place to live and raise a family."

Like all of us in neighborhoods occupying Center and Warren Townships, I am proud to call myself an Indianapolis Eastsider.

BIBLIOGRAPHY

Bierck, Greg. *The Jennifer Letters*. West Conshohocken, PA: Infinity, 2006.

Biersdorfer, Barbara, Deborah Edwards, Steve Beckley and Diane Adams. *Walking the Hardwood: Serving the Fleet from 21st and Arlington, 1942–1996*. Indianapolis, IN: Indianapolis Printing Company, 1997.

Bodenhamer, David J., and Robert G. Barrows. *The Encyclopedia of Indianapolis*. Bloomington: Indiana University Press, 1994.

Corcoran, Kevin, ed. *Little Flower Parish History*. 2005.

Dugdale, Dorothy. *My Rear View*. N.p.: D. Dugdale, 1989.

"Efficiency, Attention Featured at Sirloin Inn." *Indianapolis Star*, August 9, 1964.

Korra, Herbert M., and Wendy W. Paige. *The History of Warren Township*. 2nd edition. N.p.: [1991?].

Larson, Erik. *The Devil in the White City*. New York: Vintage Books, 2003.

Lutholtz, M. William. *Grand Dragon*. West Lafayette, IN: Purdue University Press, 1991.

McCleery, Bill. "Navistars' Closing Stirs Memories, More Concerns." *Indianapolis Star*, January 31, 2009.

Moore, Rebecca, Janet Shular, Tim Carter, Stanley Clayton and Hue Fortson Jr. *Jonestown: The Life and Death of the People's Temple*. DVD. Directed by Sandy Nelson. Alexandria, VA: PBS Paramount, 2007.

"1935–2008…and Beyond." *East Side Herald*, November 20, 2008.

O'Neal, Kevin. "Will the 2nd Time Be the Charm?" *Indianapolis Star*, March 1, 2009.

Riley, James Whitcomb. *The Complete Poetic Works of James Whitcomb Riley*. N.p.: Kessinger, 2005.

Ritchie, Carrie. "Extreme Emotions for Indy Dad." *Indianapolis Star*, April 5, 2009.

Smock, David. *The History of Scecina Memorial High School*. Unpublished paper, n.d.

The Story of Technical High School. Published by the press of Arsenal Technical High School as supplement to the *Arsenal Canon*, n.d.

Ziegler, Connie. "Indiana Amusement Parks 1903–1911: Landscapes on the Edge." Master's thesis, Department of History, Indiana University, 2007.

Websites

www.algreensdrive-in.com
www.deadmalls.com
www.polis.iupui.edu
www.rivolitheatre.org
www.truecrimelibrary.com
www.woodruffplace.com